The art book for children

What's inside?

Making faces

Here are four sideways views of strange-looking men. Their faces are made up of fruit, flowers, vegetables, and leaves.

Who are these men? **And why has Giuseppe Arcimboldo chosen to look for ideas in a grocery store?** In fact, these four pictures are not portraits of real men, but portraits of the seasons—spring, summer, fall and winter. Each man is made up of the fruit, plants, and vegetables that grow at that time of year. Spring is the first season, so the spring man looks the youngest, then comes summer, then fall, and finally, old man winter.

Look at *Summer*. Arcimboldo has painted a picture of the summer season by making a man shaped from all the delicious things that ripen in the hot months: fruits like plums, raspberries, and pears, and vegetables, such as cucumbers, a corncob, and an artichoke. *Summer's* lips are cherries, his eyebrow is an ear of wheat, and his cheek is a big ripe peach. His teeth are peas, his nose is a cucumber, and his chin is a pear. How many fruits, vegetables, flowers, and plants can you find in these four pictures?

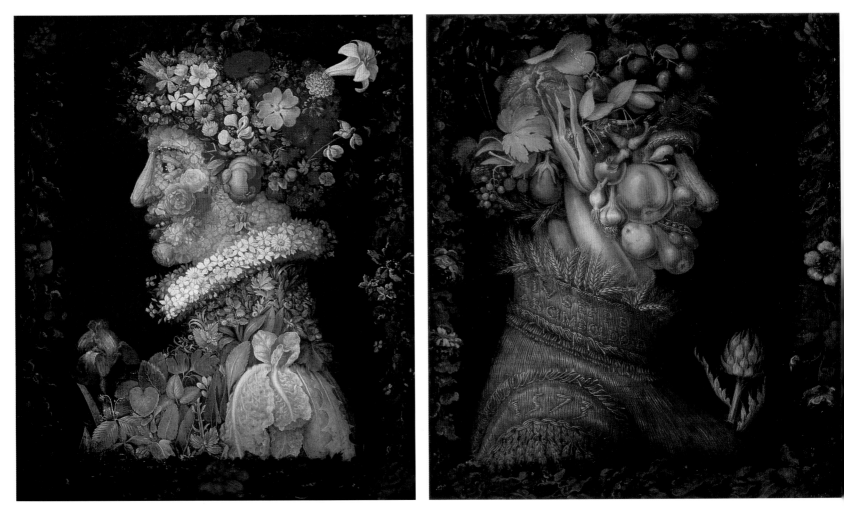

Spring *Summer*

If you were to make up a face in this way, what would you use?

A mechanic could be made up of bolts, screws, and spanners, a mailman could be made up of an envelope, stamps, and an elastic band.

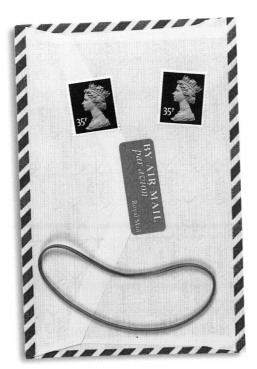

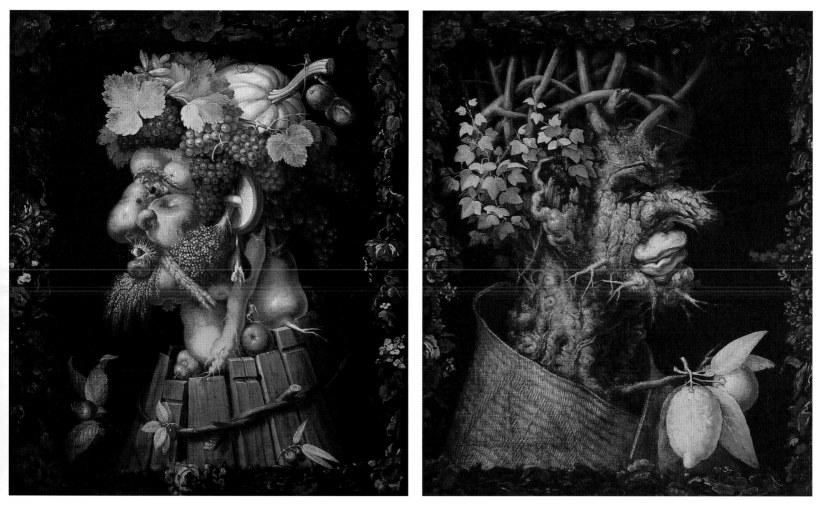

Fall

Winter

Living sculpture

Multicolored suits, odd pairs of shoes, red and blue hair, yellow sky, and a green apartment building, all made to look a bit like a stained-glass window. I think it's safe to say that these artists aren't trying to make anything look like it does in real life.
So what are they trying to do?

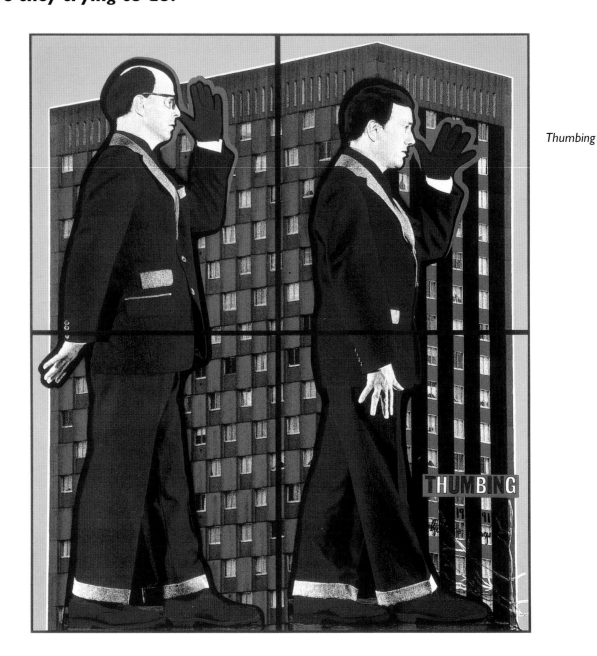

Thumbing

What are Gilbert and George "thumbing" their noses at, or making fun of, in this picture? Are they making fun of traditional art? Or perhaps they're thumbing their noses at all the serious people who don't realize that art can be fun?

Gilbert and George are two people, but they behave as if they are one. Although not related to one another (Gilbert is Italian and George is English), they dress in the same way and are never seen apart, whether walking to the store to buy food, or appearing in a museum as a work of art. Gilbert and George are the artists, but they are also the subject of the art that they create.

They call themselves a living sculpture. Once, dressed in smart suits, their hands and faces sprayed with metallic paint, they stood on a table in a gallery and, very seriously, mimed a song all day long, day after day. Can you imagine doing this? **Would you be able to keep a straight face?** They did.

The Singing Sculpture

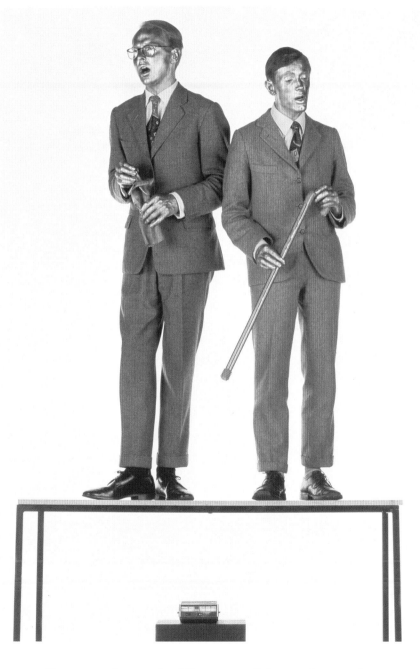

Gilbert and George are unlike any other artist. They are a living sculpture that creates art. Can you imagine leading a life where everything you do is done with someone else, and everything you do together is seen as art?

A party

Can you hear the noise in this picture? What a racket! Bagpipes, the clanging of plates and jugs, people chattering. The musician in the red jacket has stopped playing to stare at the food being brought in, and a man grabs a full plate from the tray to pass to other guests at the long table. The food must be delicious. The child wearing a red, floppy cap with a peacock feather is eating every last crumb on his plate with his fingers. Even the small child at the far end of the table looks as if he or she is munching away.

This is a party—a wedding party—that takes place in a barn. The yellow walls are stacks of hay. The bride is not dressed in white, but in black, sitting in front of a blue-green cloth. Her eyes are closed, but she seems to be smiling. In those days, the bride was not allowed to sit next to her groom at the wedding table. We can only guess who her new husband is. Perhaps he is the man with his eyes wide open, three seats to her right, stuffing a spoon into his mouth.

Do you think it's cold in this room? Remember that it's a barn! Notice how everyone wears something on his or her head. It may be a cap, a scarf, or a hood. Can you find a wooden spoon stuck in someone's hat?

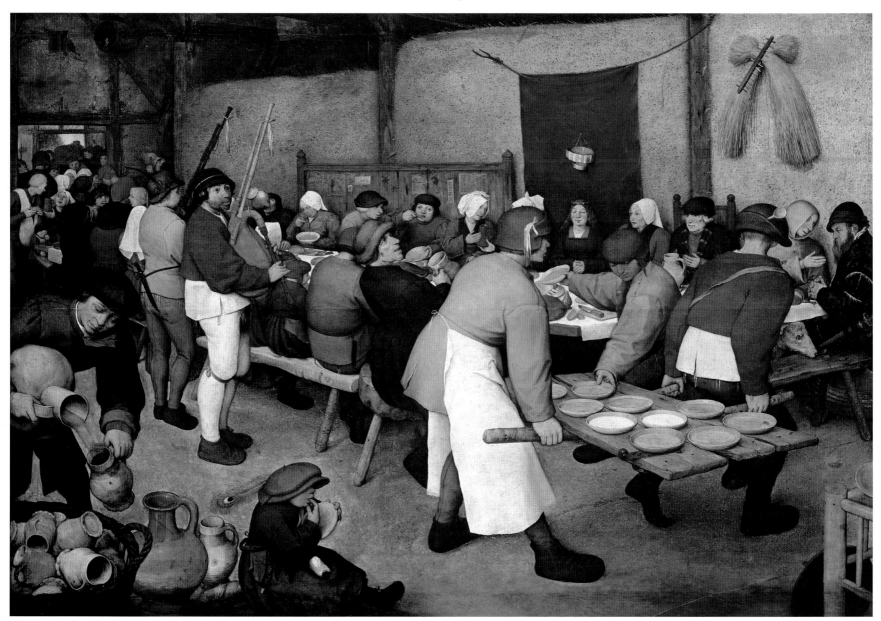

There are so many details in this picture. Look at the large tray that is being used to bring in the plates. It's actually an old door! You can see one of the hinges on the left-hand side.

There's also something strange going on underneath the tray. The man with the red jacket seems to have three feet rather than two! Who does that third foot belong to?

Many of Pieter Bruegel's paintings are full of people, laughter, and noise. He was a great storyteller and, thanks to him, we know something of what life was like over 400 years ago. From this painting we can tell how people dressed, what musical instruments they played, and how they celebrated a country wedding.

SPLAT

What a mess! Drips, splashes, and dribbles of paint are all over the floor.

Jackson Pollock's paintings look careless and unplanned, but in fact they are not. He took great care over where the paint would fall and which colors to use. He sometimes made layers of different colors land on top of each other, so that the paint was very thick, keeping other parts of the canvas bare. With a flick of his wrist he let the paint fall off his brush in loops and swirls, splat, onto the canvas.

Although it looks messy and easy, this is a very difficult thing to get right. Pollock is one of the most important artists of the last 50 years, mostly because he invented a whole new way of painting. He pinned giant canvases to the floor, and danced around them, flinging paint straight out of a can—sometimes with a stick instead of a brush. This is called Action Painting because it's much more energetic than old-fashioned painting, where the artist stands still in front of an easel.

Pollock's paintings are abstract, which means that they don't represent anything that we can see. But they do tell us a bit about the artist's energy and emotions. **What do you think Pollock was feeling when he painted _Number 1, 1948_?** Excitement? Confusion? Anger?

Pollock signed this painting in two different ways—with his name, and with his hands.

Can you find these signatures over the page?

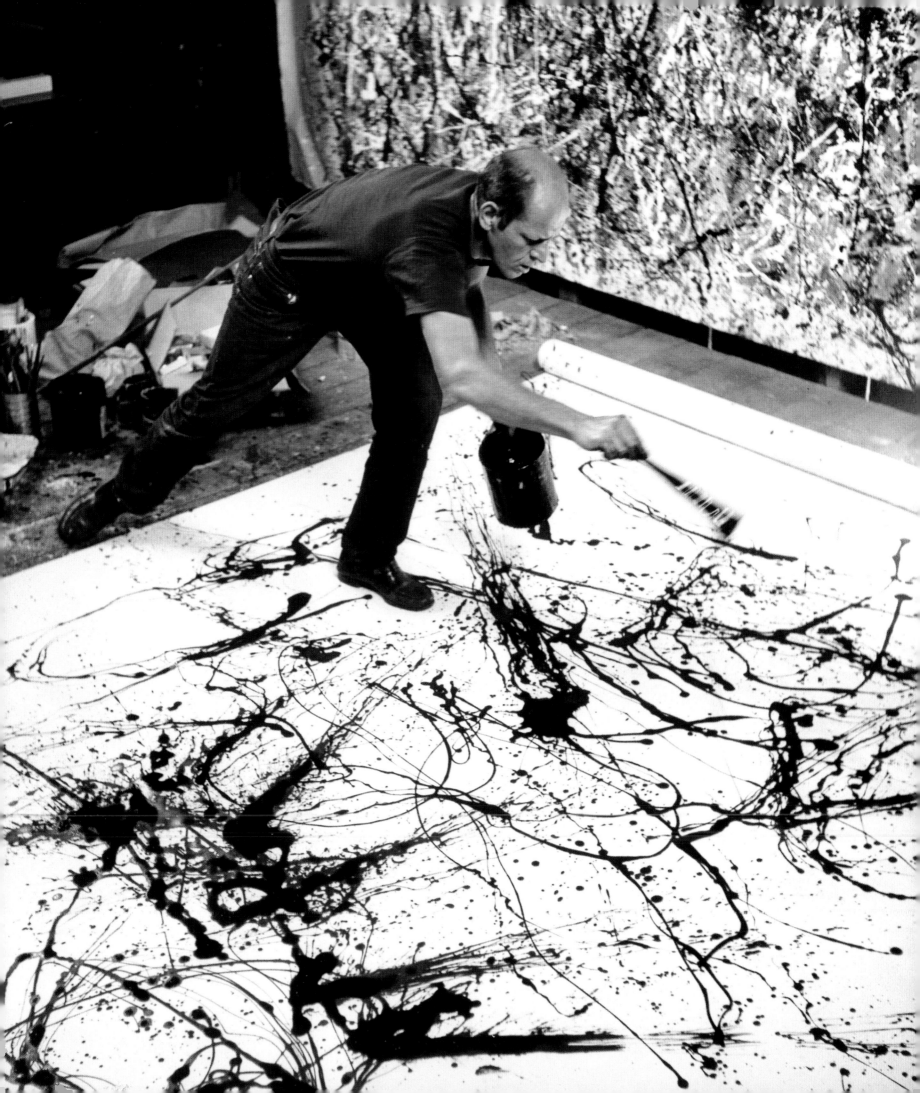

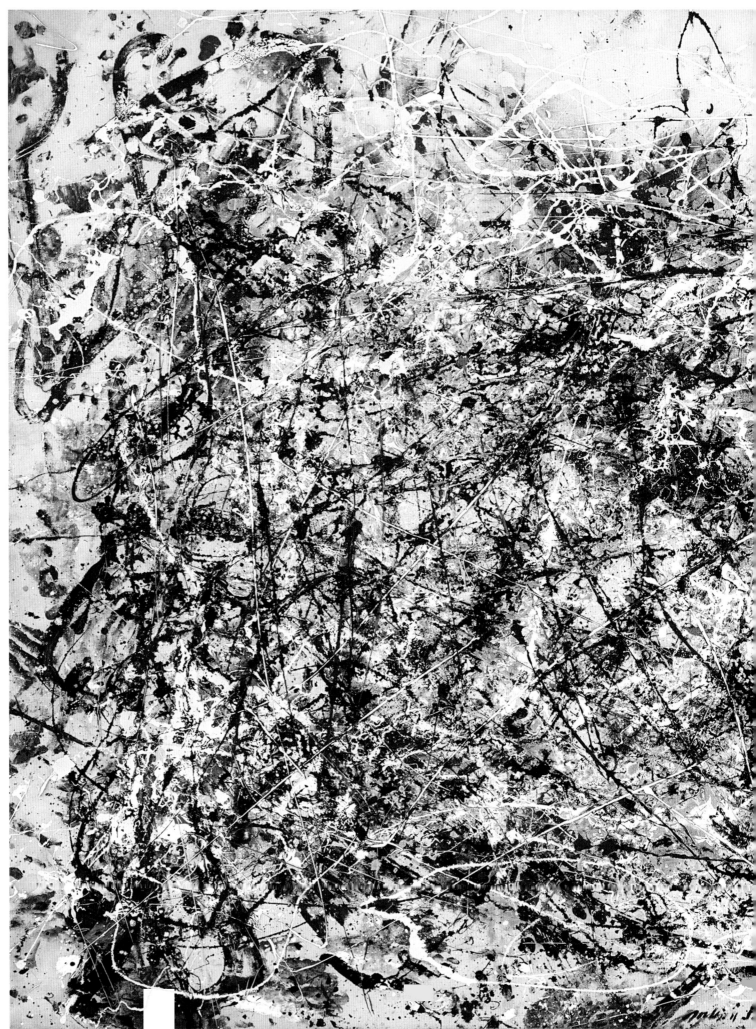

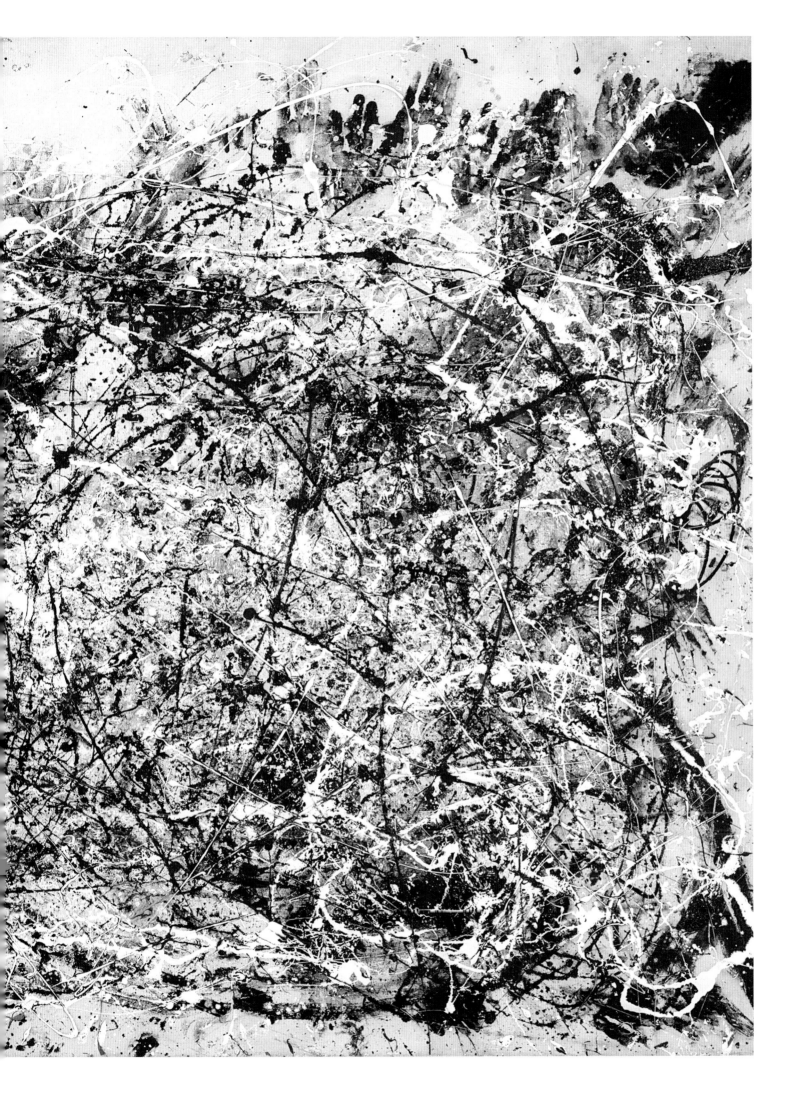

A mystery

The *Mona Lisa* is probably the most famous portrait in the world, but not much is known about it. The picture was so important to Leonardo da Vinci that, although he painted it for someone else, he refused to give it up, and kept it with him until he died.

Who was Lisa? We are not completely sure who the lady in the picture was, but her name was probably Lisa del Giocondo. *Mona* is a shortened form of *madonna*, which means "my lady" in Italian. So the title means "my lady Lisa".

Where is Lisa? Is she standing, or is she sitting on a throne? Look at the scenery behind her. Is she in front of a window? Are the lakes, roads and mountains behind her real, or are they part of a picture hanging on the wall behind her? Perhaps they are just from Leonardo's imagination.

What is she thinking? Look into her eyes and at her mysterious smile. Is she happy? Is she sad? Maybe she's just bored.

The more you look at Mona Lisa, the more you feel that she might suddenly move her gently folded hands and come to life. She might even explain her mysterious secrets!

We don't know, for sure, who she was, where she is, or what she's thinking.
Why do you think this picture was so important to Leonardo?
No one knows the right answer, so your guess is as good as mine!

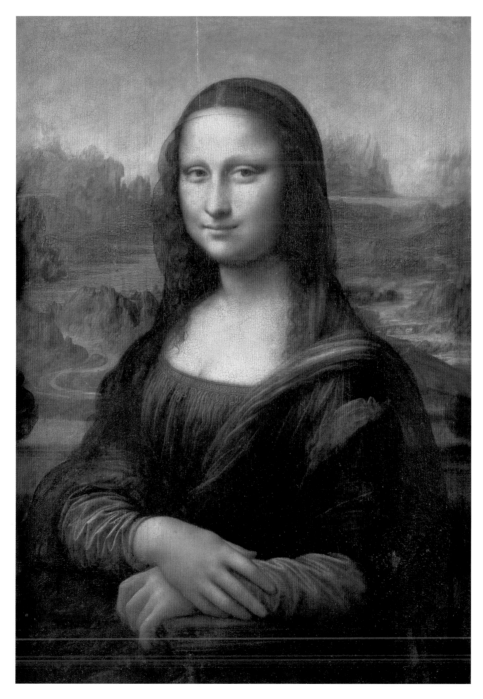

Mona Lisa

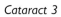*Cataract 3*

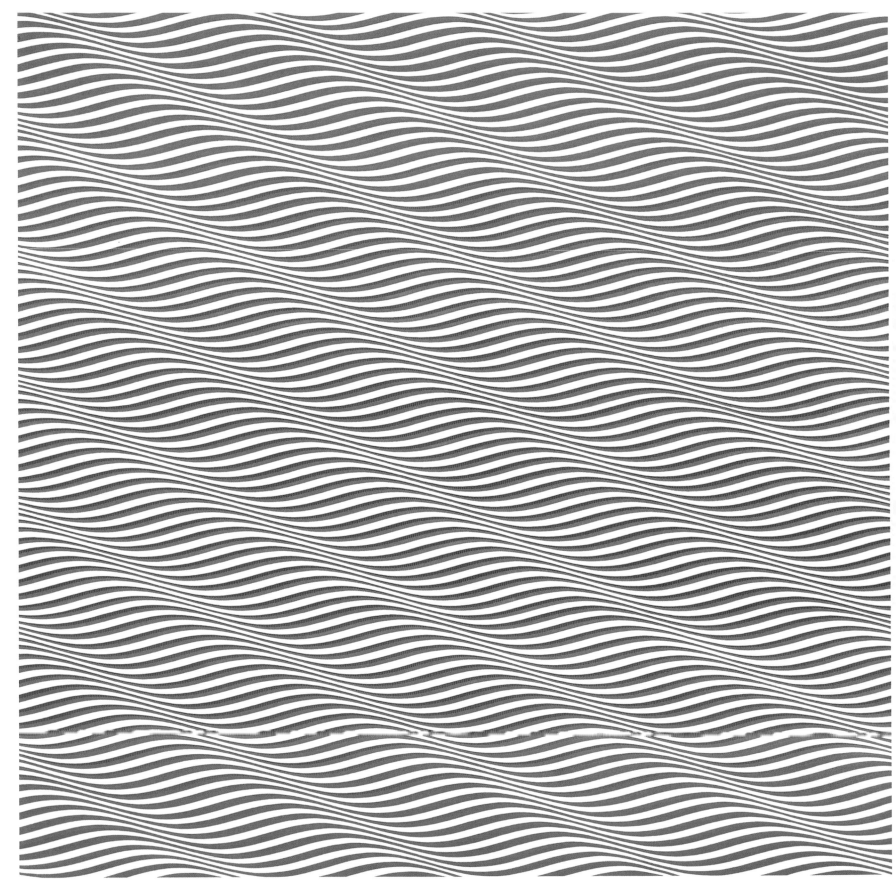

Moving pictures

Bridget Riley's paintings are abstract—they do not show things that we can see. Although some people have compared the painting on the left to a wave, a flag in the wind, the surface of a swimming pool, a mountain range, and sand rippling across a windswept desert, these comparisons are not what Riley is interested in.

She is what's called an Op artist. She's not interested in *what* we see, but in *how* we see. She's interested in how our eyes work when we look at things. The proper word for this is "optics". *Cataract 3* is painted on a flat canvas, but by carefully placing the red and gray wavy lines together, Riley has created an optical illusion—something that our eyes think is wavy, not flat.

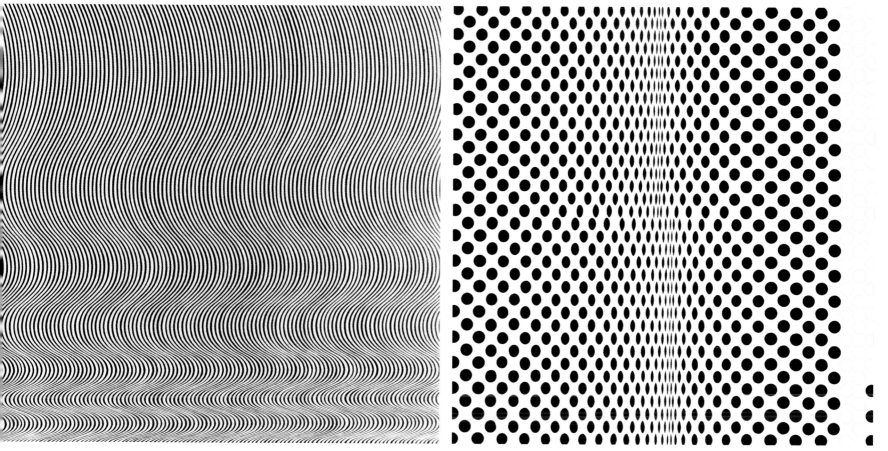

Fall

Fission

Do these pictures look as if they are moving to you? If you look at them for long enough the lines almost begin to drift across or wriggle down the picture. If you look very carefully at the very center of the picture on the right, you can see how the artist has varied the position of the circles and ovals to create a sense of movement or splitting apart (which is what the title *Fission* means).

Gods and goddesses

This picture looks like a garden where someone has stored some marble statues.
Two of them look out at us, but they don't seem to have noticed the other people
in the garden. What are they all doing in the same picture?

On the far right is a grayish figure. He is Zephyr, the west wind.
His strong, long wings (hidden behind the branches) help him move
the wintry clouds away and bring in the warmer spring weather.

Zephyr has been chasing a beautiful young girl called Chloris. As he
captures her, her breath turns into flowers, which you can see falling
from her lips.

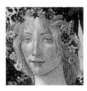

Once caught, Chloris is turned into Flora, the goddess of flowers.
The flowers spill from Chloris' mouth onto Flora's dress, and Flora
scatters them onto the grass beneath their feet.

The woman in the middle of the painting is thought to be Venus,
the goddess of love.

Flying above her is her son, Cupid. He seems to be aiming his bow
and arrow at the three blonde women holding hands.

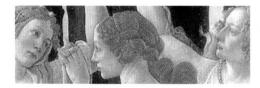

These are the Three Graces, the attendants
(helpers) of Venus.

On the far left, with his hand on his hip, stands Mercury, the son
of Jupiter, who was the god of sky and weather.

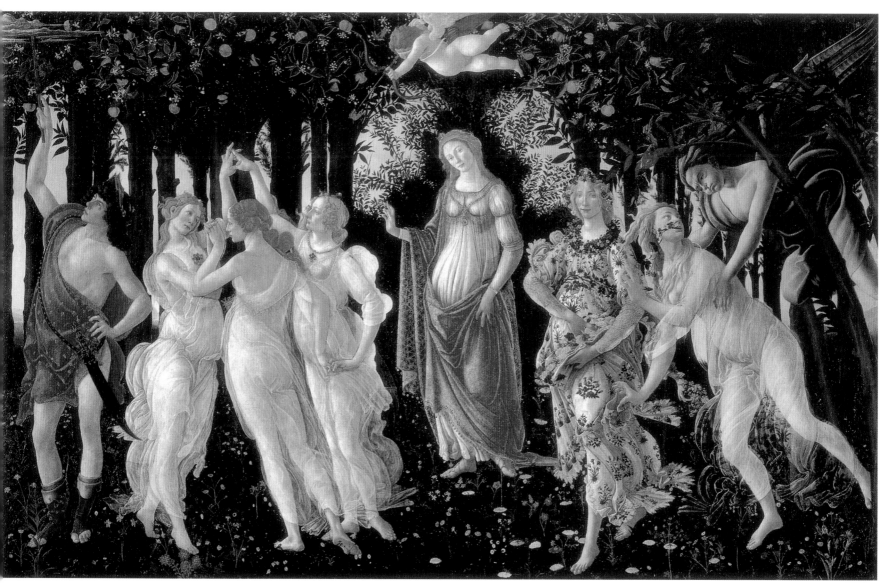

This is quite a gathering, and no one knows exactly what Botticelli was trying to tell us when he put all these figures together. But when you know who they all are, it seems possible that Mercury, who is pushing away the clouds with a kind of magic wand, is announcing the arrival of spring.

Obsession

Hokusai was obsessed with Mount Fuji, the tallest mountain in Japan. Although this is one of a series of pictures called *Thirty-six Views of Mount Fuji,* we know that he actually made 46. His pictures show the mountain from different angles with various people and sights in the foreground. Mount Fuji appears with cranes, with a fisherman, with three men on horseback, with a great wave, with a timber yard, and with a kite. Look at them below.

Of all the pictures he made of the mountain, the larger one on the opposite page is probably the simplest and the most famous. Hokusai wanted to show the mountain in the early morning, so he has made it a glowing red color as if lit by the rays of the rising sun. There are only three colors in *Red Fuji:* red, blue and green. There is very little else in the picture apart from trees and clouds. Hokusai wanted to keep everything as simple as possible so that nothing distracts from the majestic mountain with its snow-covered peak.

There may be hundreds of copies of this picture all around the world. It is a woodblock print, made by Hokusai and a printmaker. Hokusai would have made a drawing for the printer to carve into a block of wood. Different colored inks would have been applied to the woodblock, which was then pressed against a piece of paper.

Prints are much easier to transport than paintings. They are usually smaller and definitely lighter. Prints like these were sent all over the world and influenced many artists, not just in Japan, but also in America and Europe. We know that Vincent van Gogh loved Japanese prints.

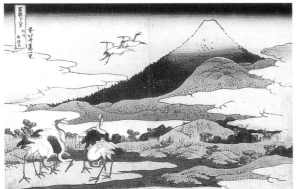

Mount Fuji with Cranes

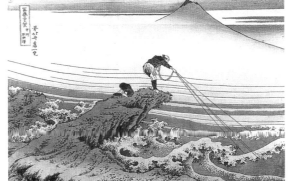

Mount Fuji with a Fisherman

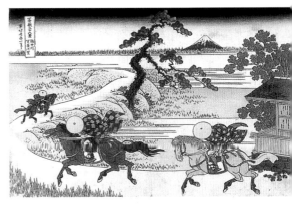

Mount Fuji and Three Men on Horseback

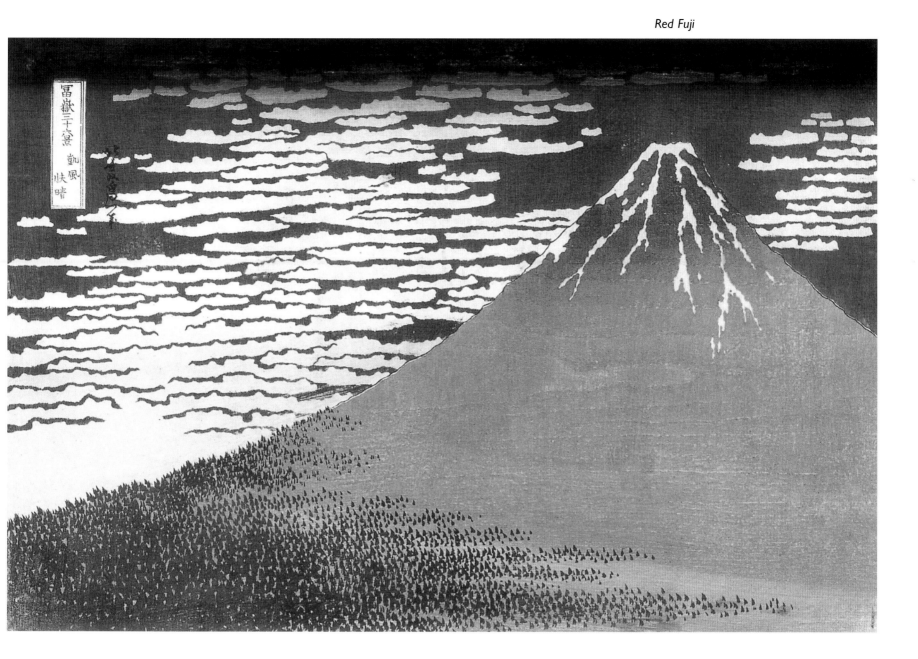

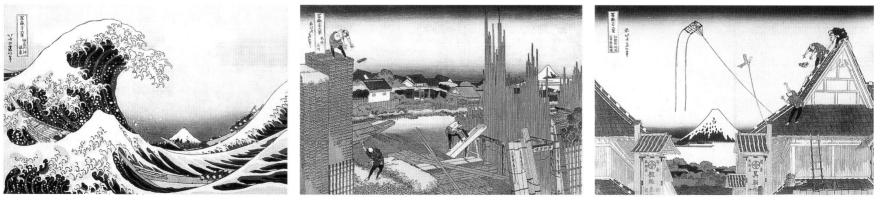

Mount Fuji and the Great Wave *Mount Fuji with a Timber Yard* *Mount Fuji with a Kite*

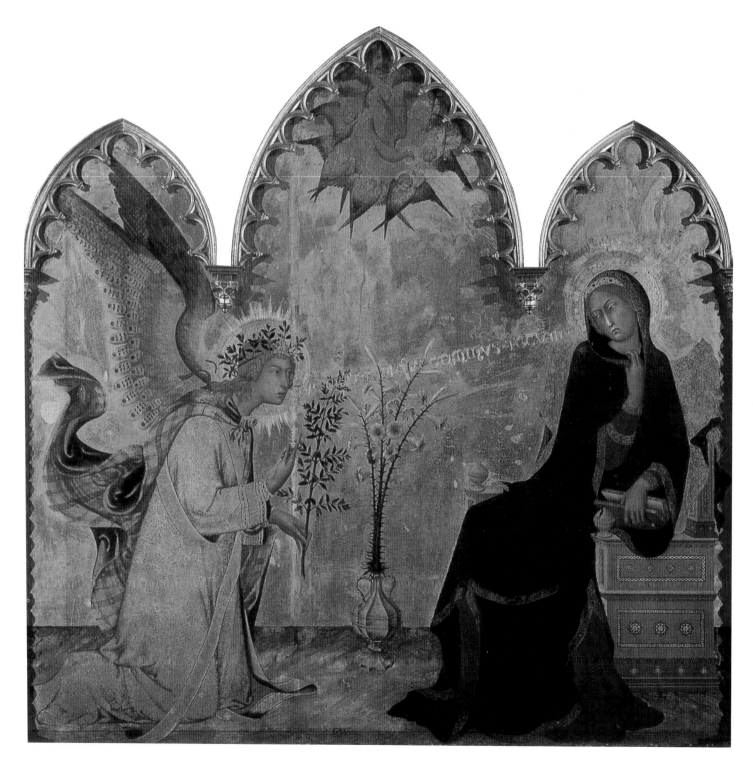

The Annunciation

A cartoon

This is probably the oldest cartoon you have ever seen! The angel on the left has come to deliver a message to the woman on the right. We can read the words coming out of his mouth. Instead of being in a bubble, as you would find in a cartoon or comic book today, his words are written across the painting.

The message is in Latin and reads *Ave gratia plena Dominus tecum* (Greetings, you who are full of grace, the Lord is with you).

The angel Gabriel, with his wings still open and his cloak still billowing, has just flown in to announce to Mary that she is expecting a baby. Although the angel looks like a woman, with long hair and a dress, traditionally angels are usually male. Mary has been quietly sitting at home reading a book, and is taken by surprise. She even looks a little scared. She holds her cloak tightly around her as if to protect herself from this strange visitor.

Wouldn't you be a little frightened if someone had just flown in through your window?

Cartoons are made to tell stories, just as this painting was. Today, cartoons are usually printed in magazines or comic books that you can carry around easily. This cartoon is painted on a piece of heavy wood, and would have been made to go above an altar in a church for people to look at while they were praying. It wasn't designed to be read on the bus!

The Pont Neuf Wrapped, Paris, 1975–85

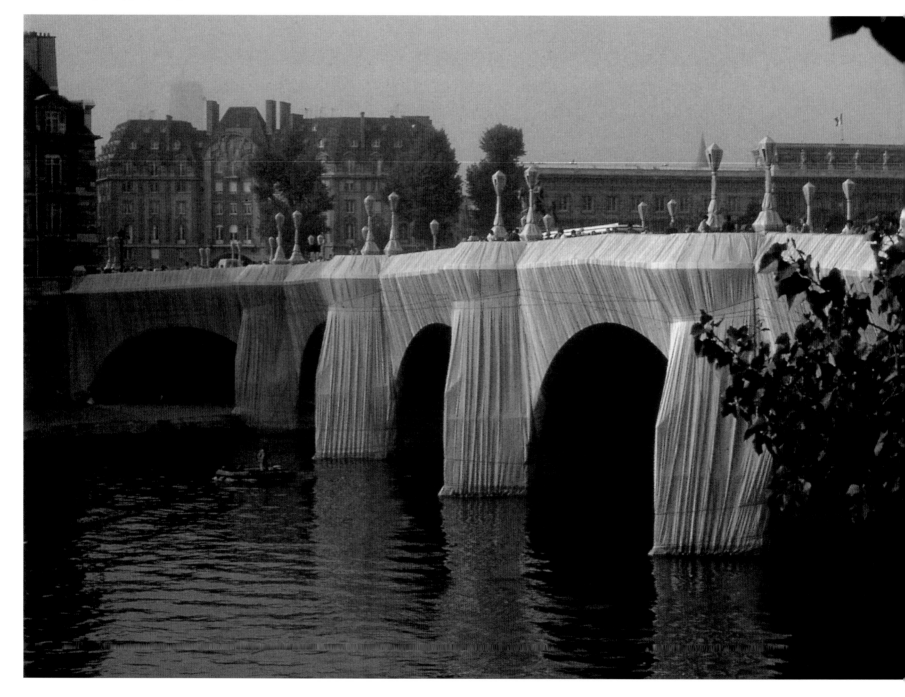

Wrapped up

Who allowed Christo and Jeanne-Claude to wrap this famous Parisian bridge in fabric?

Did they sneak up one night while no one was looking? Absolutely not! It took 10 years of preparation, 300 skilled workers, 439,989 square feet of fabric, 42,900 feet of rope and eight permits from the Mayor of Paris, Mayor of the Fourth Arrondissement, Ministry of Culture, Police Department, Fire Department, River Traffic Department and the National Historical Monuments Department!

The result was a monumental sculpture that lasted for only 14 days. During those 14 days the bridge looked totally different, but boats still sailed under it and people and cars still walked and drove across it.

We normally wrap things to hide or protect them. When Christo and Jeanne-Claude wrap things they draw our attention to them.

In 1980, Christo and Jeanne-Claude began a work in Biscayne Bay in Miami, Florida. Having secured permissions from eight different people and institutions—including the Governor of Florida, the City of North Miami, the US Army Corps of Engineers and local environmental organizations—they removed 40 tons of rubbish from 11 small islands in the bay and eventually constructed nine enormous pink "belts" made of nylon, that fit snugly around the islands and floated on the water's surface (seven islands each had their own belt and two pairs of islands fit into a single belt each). For 14 days the islands that had been ignored and so badly looked after became beautiful shapes like flowers floating on a lily pond.

We know what the wrapped bridge and surrounded islands looked like from photographs. But a large part of Christo and Jeanne-Claude's work is invisible. It might take up to 10 years for them to make a work of art and the research and preparation are a very important part of the project. They need to decide where to make the next project and what to do there. Christo creates drawings, collages and scale models. They negotiate with governments and institutions and seek permissions. The organization is just as much part of the art as the completed work of art itself.

Christo and Jeanne-Claude have wrapped museums, a fountain, one million square feet of coastline in Australia and Germany's government building. If you are lucky enough to see a work by Christo and Jeanne-Claude it's a great experience. But remember, it's only one part of the whole project. Most of their time was spent on its organization.

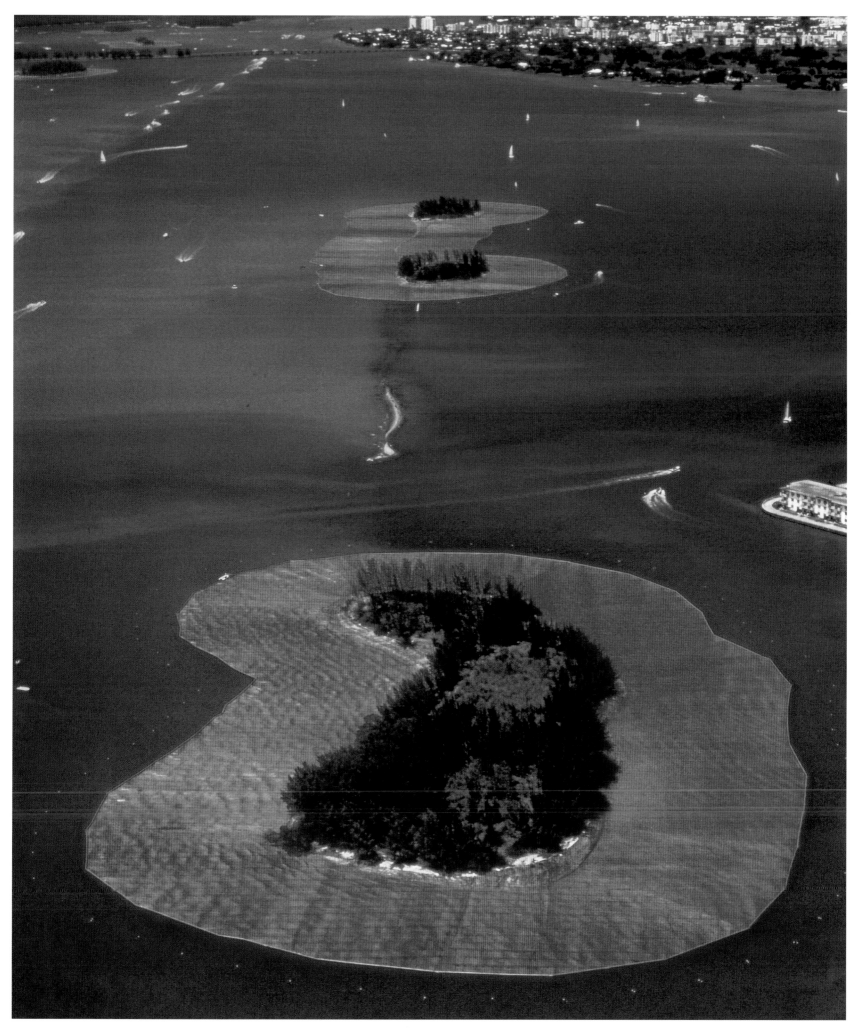

Surrounded Islands, Biscayne Bay, Greater Miami, Florida, 1980–83

Jacopo Bassano

Noah's ark

How many different pairs of animals can you see in this picture? There are sheep, dogs (one standing and one sleeping), rabbits, turkeys, horses, goats, lions, reindeer, hares and foxes. How many other pairs can you find? There are at least five more.

This isn't a painting of a barnyard, but Jacopo Bassano may have spent some time on a farm or at a zoo. He must have studied the animals very carefully to paint them so well in this picture.

The man standing in the middle of the picture is Noah who, according to the Bible, saved all the animals from a terrible flood that covered the earth. He built an enormous wooden boat, or ark, to house the animals and keep them safe until the water had gone down. Just above Noah's head you can see the animals walking up a ramp into the ark, which will become their home for 40 days and 40 nights.

The surprising thing about this picture is how calm the animals all seem to be. It doesn't seem possible that the dogs would be able to resist running after the ducks and rabbits, or that a cat would sleep so peacefully next to a dog.

Can you imagine all these animals in one place?

All that neighing, barking and growling—the noise would have been unbearable! But here they all seem so quiet.

Of course, Bassano hasn't painted all the animals in the world in this picture. How many others can you think of?

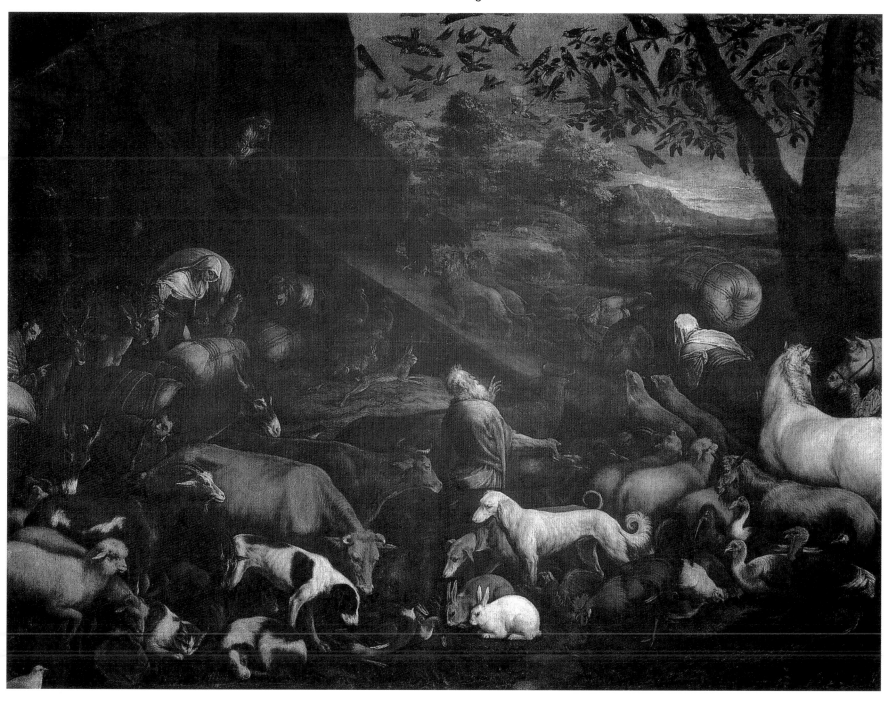

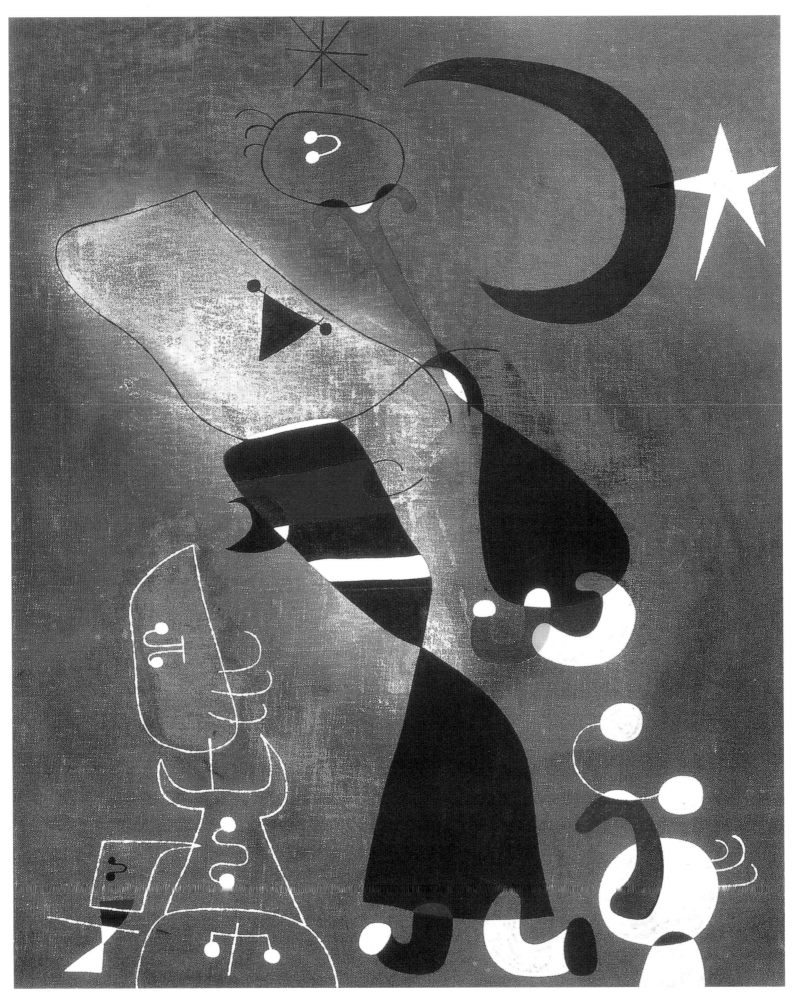

Women, Bird by Moonlight

Shapes

This picture is called *Women, Bird by Moonlight*. We can see a big, blue, crescent moon and a white star, so we know it's night time, but where are the women and the bird? **Does anything look like a bird or a woman to you?** Perhaps each pair of little circles is a set of eyes. Perhaps the large, black shapes are the women's skirts or dresses. Maybe the bird is that strange, white shape in the lower, right-hand corner, with a red beak and three, hair-like "feathers" on its round back.

Nobody can say for certain. What's your guess?

Joan Miró's art teacher once asked him to try drawing simple shapes, like circles, rectangles, stars, and triangles, wearing a blindfold. The result might have looked something like the shapes in this picture.

Why don't you try drawing a woman and a bird with your eyes closed?

Woman?

Woman?

Bird?

Where's the subject?

When you look at most of the paintings in this book, you'll see that the main subject is in the center of the picture. If you look at the middle of this picture, you might guess that its subject is floorboards!

Degas has painted ballerinas rehearsing, but they are not in the center. In fact, all the action is taking place towards the edge of the painting, and perhaps even outside it.

The girl sitting with her feet apart seems to be more interested in something that is happening outside the picture frame. She might be looking at her friend on the far right, who is only half in the picture. We can't even see her face and hands properly, so we don't know what she is doing. The ballet master, in his red shirt and sweater, is on the other side of the room, behind the woman who might be taking something out of a big box on the floor. Another ballerina is masked by the spiral staircase—only her legs and the corner of her skirt are visible—and there's another dancer who is just about to walk down the staircase into the picture.

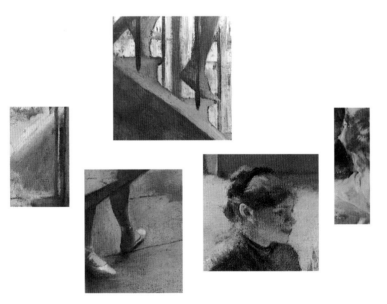

None of these figures, half in and half out of the picture, is like that by chance. Degas has composed this painting very carefully to make it seem as if he is spying on the ballerinas through a half-open door. It is as if he has quickly and quietly taken a photograph of them without looking through the camera's viewfinder first.

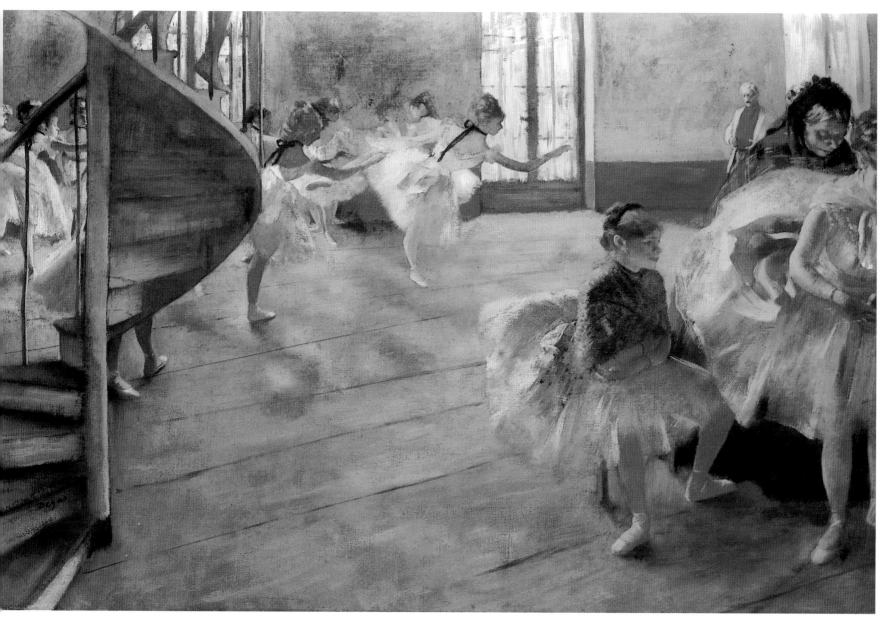

The Rehearsal

Tears

Have you ever seen yourself cry? Do you ...

Your face might turn white or red, and your eyes and mouth might change shape.
Perhaps that's what is happening to this weeping woman—her face has changed
in shape and color from crying so hard.

Even by the time he was eight, Pablo Picasso could draw more realistically than
his art teacher, so he invented new ways of drawing people and things. The results
could be quite strange: for example, this woman's mouth is turned in a different
direction from the rest of her face. Her eyes seem to be looking straight at us,
but her lips and teeth are in profile (seen from the side). It's as if you can see her
from two different directions at the same time.

Picasso wanted to show this woman's unhappiness and tears rather than to create
an exact portrait of her face. The jagged shapes like pieces of glass, the bright colors
and the thick, black outlines make us think of strong feelings, like anger or sadness.
Can you imagine her sobs and her tears?

She looks as if she might be holding a handkerchief. She's wearing a red hat with
a flower in it, and her hair is neatly combed, as if she is dressed for an important
occasion. **What do you think has upset her so much?**

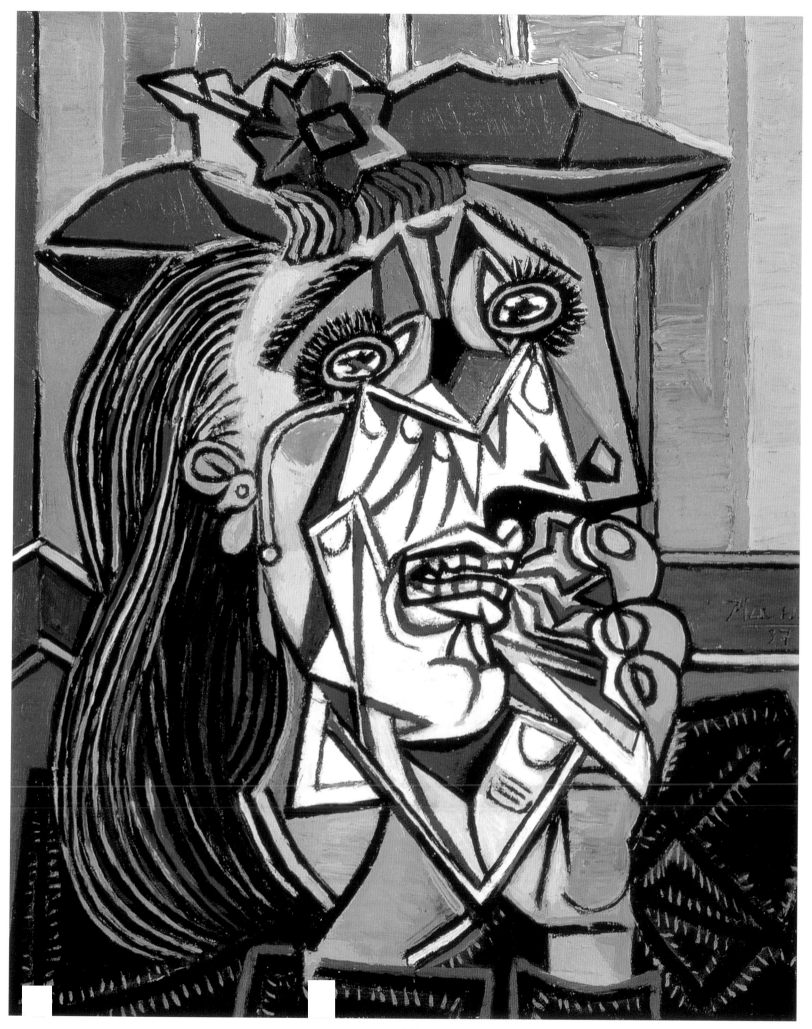

Weeping Woman

A battle

How many soldiers are in this picture? Hundreds? Thousands?
Each one is painted in detail wearing armor, sometimes a colored cloak and a plumed helmet. Some are in the middle of the battle, fighting with lances, some are being trampled by horses, and some are riding away from the danger. One soldier in the bottom right-hand corner is watching the battle. Perhaps he is the senior officer checking the progress of his troops.

Everything is painted with the same care and attention as the soldiers. Look at the grey, chestnut and black horses with their own protective armour. Look at the flags with coats of arms and mottos on them. Look further back into the picture at the ruined building, the castle on the hill, the soldiers' camp on the outskirts of town, the lake with boats sailing on it and the island, mountains and setting sun beyond.

The detail in this picture is amazing. Perhaps Albrecht Altdorfer painted everything under a magnifying glass. It must have taken him a long time. Altdorfer loved making paintings with lots of detail in them, and he also loved making paintings of nature. Even though this is a picture of a battle, half of it is made up of landscape and sky.

At the top of the painting is a sign which seems to be hanging from an invisible ceiling. The writing on it tells us that this is a picture of Alexander the Great's victory over the Persian King Darius, that 100,000 Persians were killed and that Darius' mother, wife and children were all taken prisoner. Altdorfer chose to paint it in 1529, over a thousand years after the battle actually took place. Why do you think he chose to make a picture of it all those years later?

So, if this is a picture of Darius' defeat and Alexander's victory, where are they? Here are a few clues: Alexander is on horseback, he's wearing an elaborate golden helmet, and, with his lance pointing forward, he is charging at King Darius.

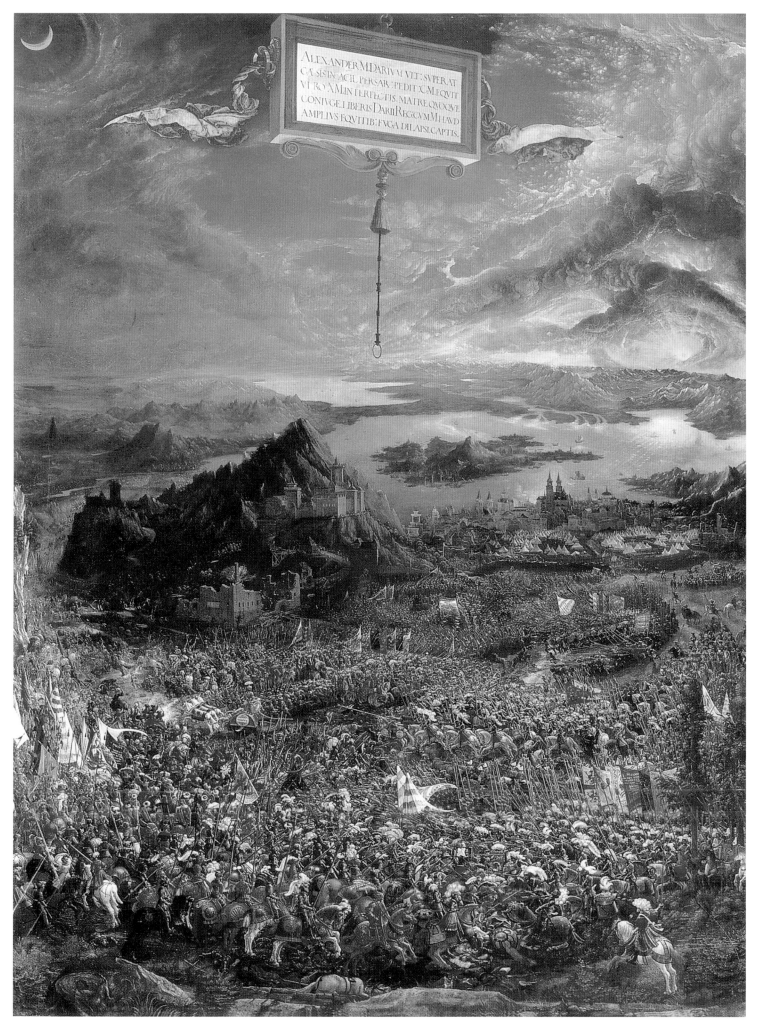

Battle of Alexander at Issus

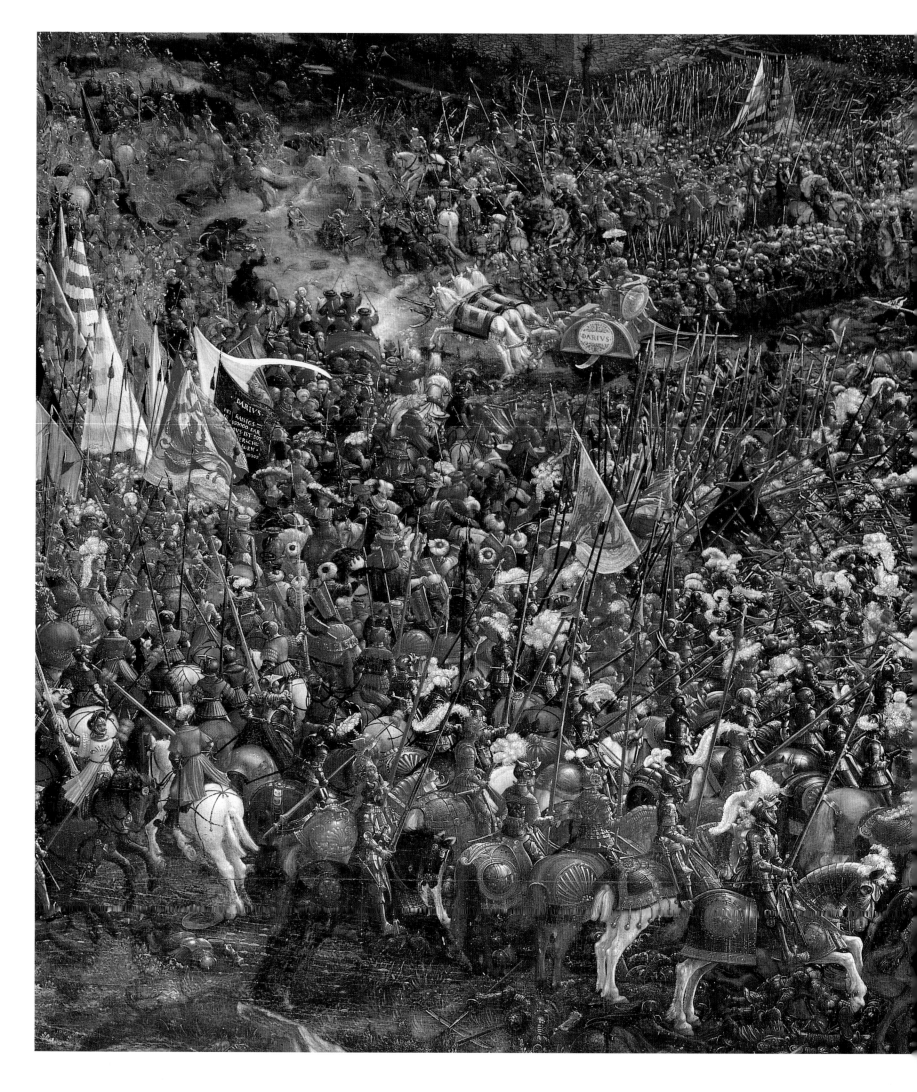

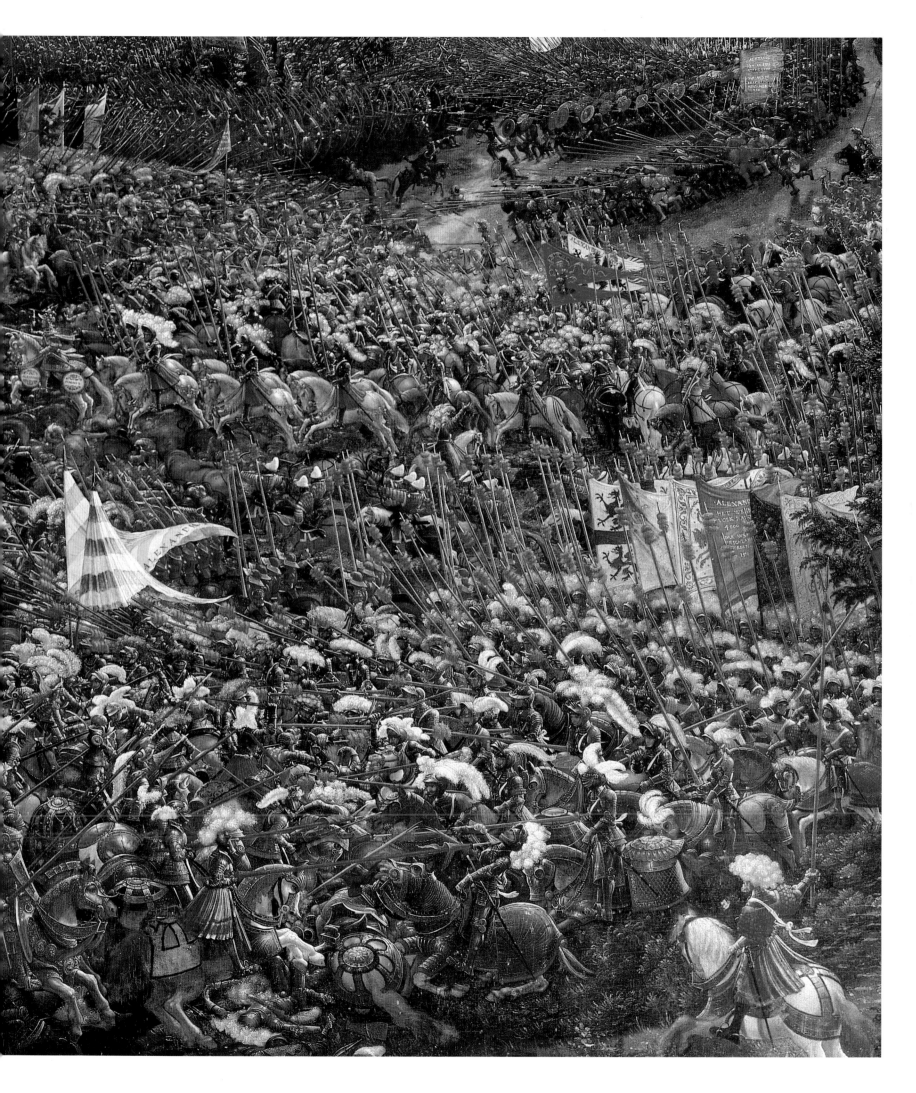

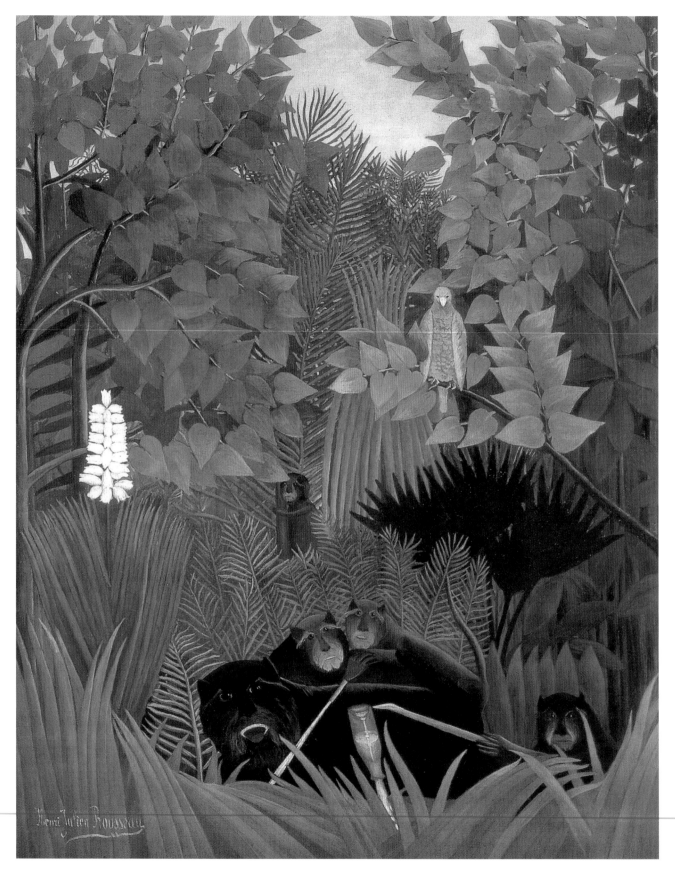

The Monkeys

A jungle

Have these monkeys been expecting us? Or are they surprised to see us? Henri Rousseau probably never saw a real jungle, so he would have studied animals at the zoo. Maybe that's why these animals all seem to be looking at us. Have you ever been to the zoo? Sometimes it feels as if the animals have come out to watch us, just as we have come to watch them. Every monkey in this picture, as well as the bird sitting on the branch, is staring straight at us. Look at that upside-down milk bottle in the foreground. You wouldn't find that in the jungle, but you might in the zoo.

Rousseau would also have gone to the botanical gardens to study these tropical plants. This picture contains the leaves from lots of different kinds of plants.

Some are long and thin.

Some are oval, or pear-shaped.

Some are more like thick grass.

Their colors range from darkest green

to light emerald

and brownish yellow.

Everything in this picture seems a little strange. It's as if every eye and every leaf is turned toward us, awaiting our arrival. Creepy!

Rousseau's first job was as a customs agent for the French government, and he only became a painter later in life. I think this painting may have been an **exercise** in how well he could paint plants and animals. Perhaps he went to the botanical garden and then to the zoo and put the drawings together to make this picture.

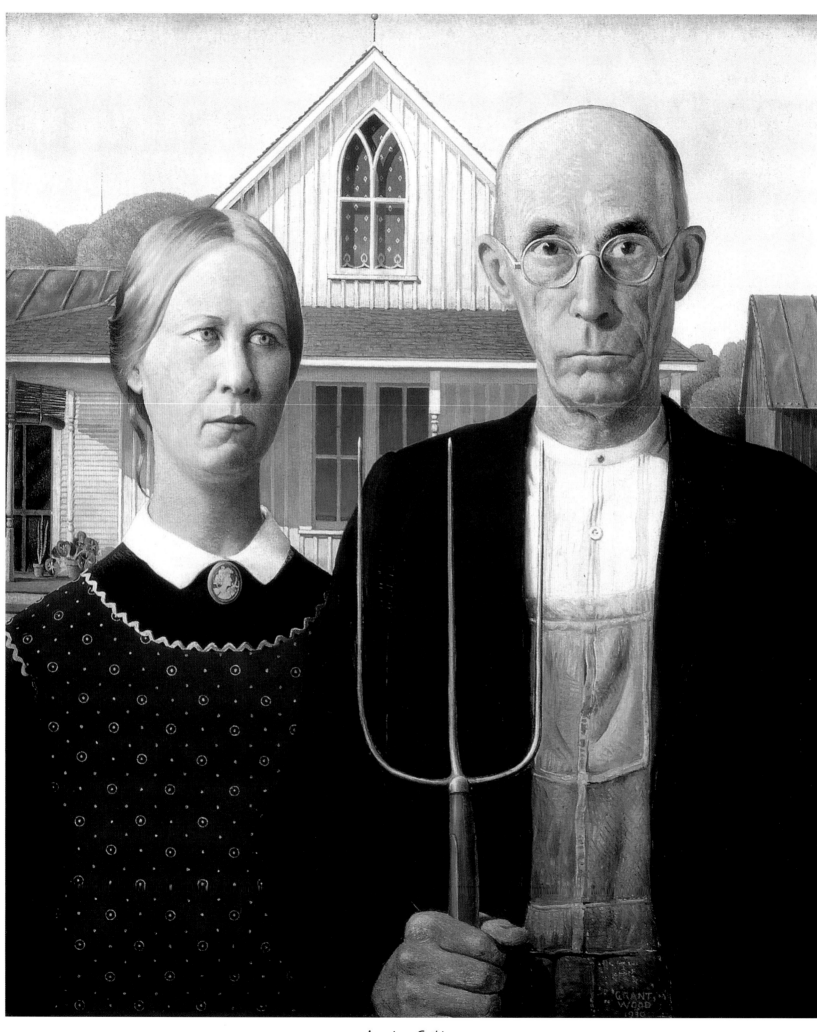

American Gothic

Spikes and circles

Has something upset the two people standing in front of a neat, white house? Do you think they are grumpy, sad, or unfriendly? The man looks like a farmer with his overalls and pitchfork, but in fact he was not a farmer at all. His real name was Dr. B.H. McKeeby, and he was Grant Wood's dentist. And the woman is not the dentist's wife, but the artist's sister, Nan.

Why did Wood choose to paint these people in this way? Some people think he was making fun of the two characters, presenting them as stiff, cold people. But maybe they're not grumpy or sad at all, just calm and dignified. What do you think—did the artist like or dislike these two people? Do you like them?

American Gothic is a painting of two people. But the artist was just as interested in painting something else—spikes and circles. So many things in this picture are hard and spiky Look at the prongs of the pitchfork (which match the shape of the seams on the man's overalls), the angle of the roof, the prickly cactus on the porch and the pointed spire far away in the background. There are lots of round shapes too. Look at the woman's brooch and dress, and the two buttons (one gold and one white) on the man's shirt.

What other round things can you see?

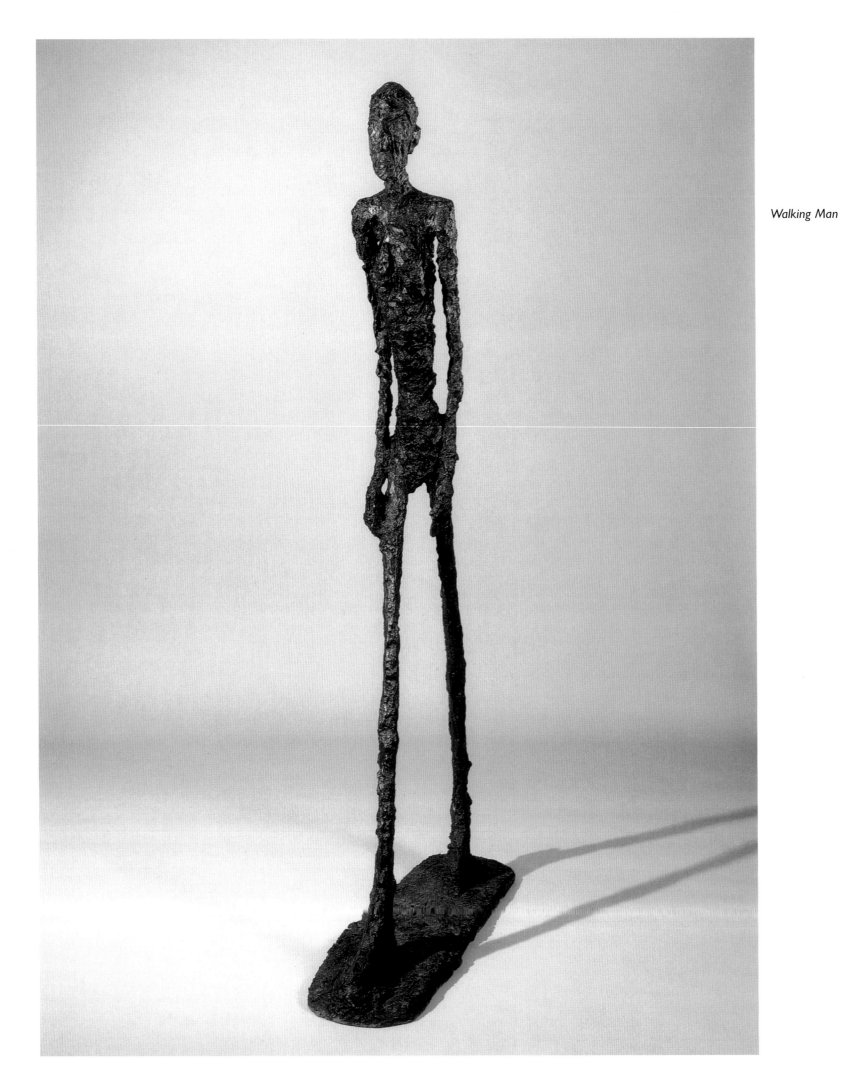

Walking Man

Frozen in time

This man doesn't look as though he's eaten much for days. His long, skinny arms and legs make him appear very fragile. There's very little we can tell about him. We don't know if he's old or young, smiling or thoughtful, happy or sad. He just seems frozen in time. He looks as if he may have been buried under the ground for years and discovered during an archeological dig. It looks as if, while under the earth, he has started to fall apart, and bits of the bronze have worn off over time. In fact, he has never been buried; Alberto Giacometti chose to make him look like this.

If Giacometti had worked in a traditional way he would have taken a piece of stone much larger than the sculpture he wanted to produce. He would have chipped and chiseled at it, cutting bits away and smoothing the edges down so that the figure emerged from the stone. Instead, Giacometti did quite the opposite. He started with next to nothing, and made the figure by adding bits, not by taking them away.

First he would have created a frame, made of thin rods of metal, in the same shape as the sculpture he wanted to create. To this he would have added small chunks of clay. He would have added more at the top to create the head, then smoothed it over the shoulders, adding more to the body than to the legs and arms. Slowly, bit by bit, he would have added the pieces so that the figure grew from the metal frame that he started with. Once all the clay he wanted had been added, the sculpture was cast in bronze to create this timeless "walking man."

Most of Giacometti's stick-like figures were made about 60 years ago. They really are like no other sculptures, and you can recognize them instantly.

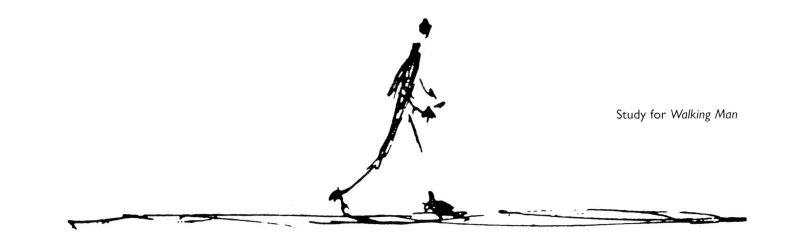

Study for *Walking Man*

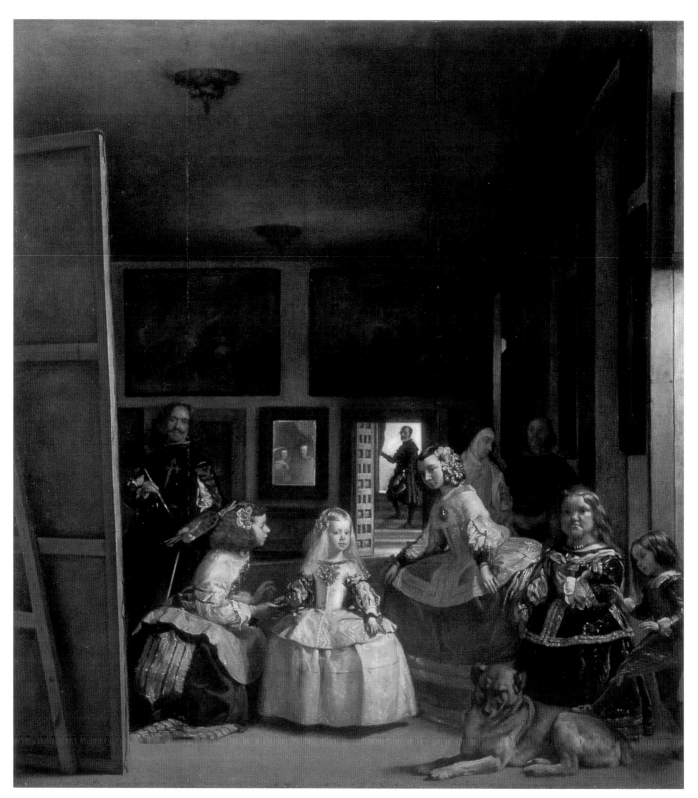

Las Meninas (Maids of Honour)

Portraits

To understand this painting, you really need to concentrate.

The pretty, little girl with long, blonde hair in the center is Margareta-Teresa. She is the five-year-old daughter of the King and Queen of Spain. At first, this painting seems to be just a picture of her and her *meninas*, or maids of honor, but in fact it's more complicated than that.

The *meninas*, with their dark, ribboned hair, are fussing over her. But Margareta is not taking any notice of them. Instead, she is looking out toward us. She's not the only person looking in our direction. So are the strange-looking lady in the black dress with the white lace trim, the man above her right shoulder, and another man standing in the doorway at the back of the picture. **What are they all looking at?** The fifth person who is looking our way is the man on the far left, the painter.

This is Diego Velázquez. He is holding paintbrushes and a palette and is standing in front of a very large canvas. It looks as if he is in the middle of painting something. What could it be? He is looking at us. **But is he painting us?** The clue is in the picture.

If you look above Margareta's head, to the left on the wall, there's something that looks like a picture of two people. But it's not a picture—it's a mirror. In the mirror we can see the reflection of the King and Queen, who must have been standing where we are. That's who Velázquez is painting.

The subject of this picture is portraits. It contains a self-portrait (of Velázquez), a portrait of the King and Queen (in the mirror), and a portrait of their daughter with her maids who are keeping her entertained while her parents sit for their own portrait.

Dressing up

Can dressing up really be art? This artist certainly thinks so. Cindy Sherman appears in almost all of her photographs—but she looks different every time. In each portrait (she has made hundreds), Sherman wears different clothes, make-up, and hairstyles. In this way, she creates many different characters. She can be young or old, silly or sad.

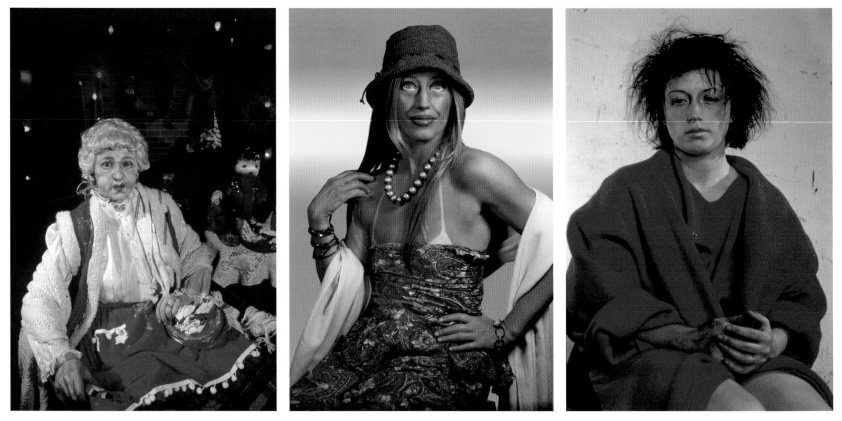

Untitled Untitled Untitled, No. 137

She can be a housewife, a clown, a singer, or a bearded man from long ago.
See if you can find all these characters here and over the page.

It's not just her clothes and make-up that tell us who she has become. She also uses different props and settings to create scenes, like mini-dramas, in which she is the star.

But Sherman doesn't try to tell us everything about a character. She leaves some things to our imagination. The young girl in the orange sweater and crumpled, checkered skirt lies on a tiled floor.

This photograph could be a scene from a movie—but we don't know which movie, who the girl is, or what has happened. It's as if Sherman has given us a snapshot from someone's life.

Why is she lying there

Is she resting

Did she fall

What's printed on the piece of paper

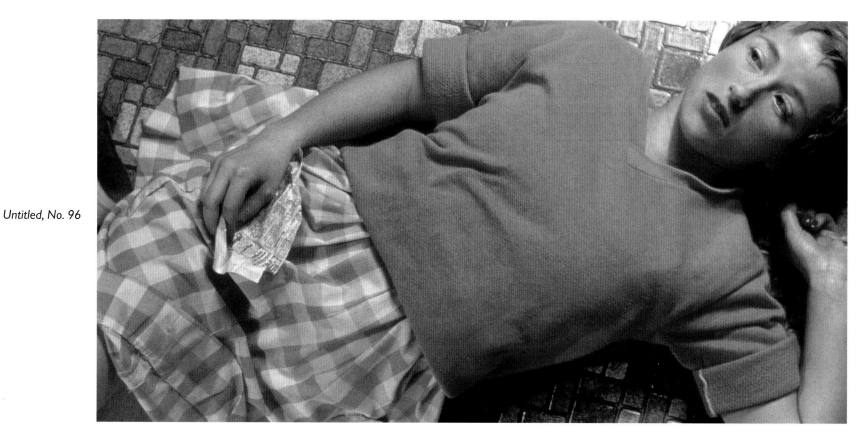

Untitled, No. 96

Did she find it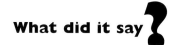

Did she read it

What did it say

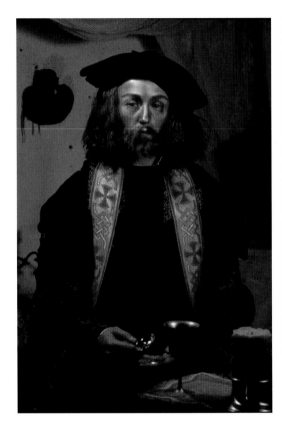

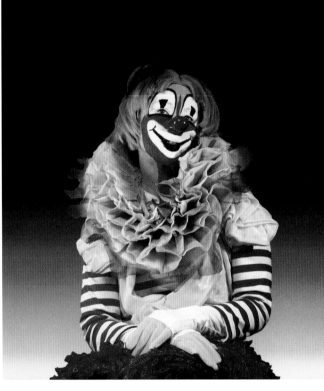

Untitled, No. 210

Untitled, No. 416

Untitled Film Still, No. 35

If you dress up, do you just change your clothes and paint your face...

Untitled, No. 119

or do you also change the way you behave ❓

A storm

The wind is howling, the waves are raging, and a snowstorm is swirling all around. There is a small paddle steamer being thrown about by the waves, desperately trying to keep afloat. **I wonder how many people are on board?** At first, this painting looks like a blur, but you can just see the ship's mast, with its tiny flag at the top.

Before painting this picture, Turner did a lot of research. He really wanted to know what it would feel like to be out on a boat in rough sea and to be lashed by the whirling gusts of cold wind as it sailed through a raging storm. So he tied himself to the bridge of a steamboat for four hours as it sailed in bad weather. In this way, he really felt the full force of the violent winds and immense waves.

Turner loved painting the weather. About 150 years ago, when Turner was painting storms and wrecks, people would have risked their lives on tiny ships like the one on the right and the one below.

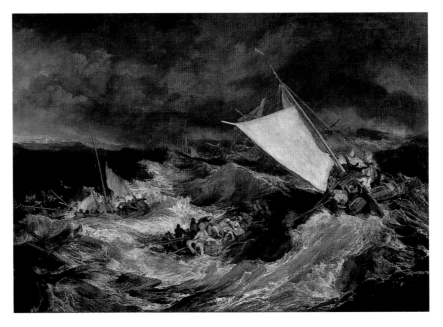

The Shipwreck

Imagine being on board in a terrible storm, as huge waves sweep around you, icy water floods the decks, and your boat is tossed by the raging sea.

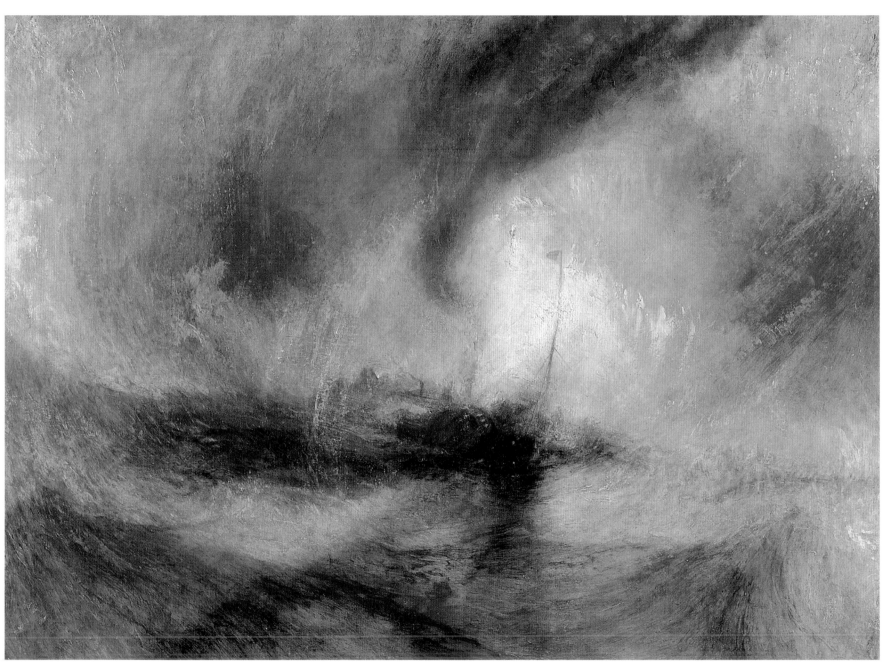

Snowstorm: Steamboat off a Harbor's Mouth

Yellow

How many tubes of yellow and orange paint do you think Vincent van Gogh used to make this picture? The flowers, the vase, the table, and the wall are all yellow or orange. The stems and leaves are the only things that are not.

Not only is there a lot of the same color, but there's also a lot of paint. Can you see how thick it is? If you ran your fingers over the surface of the picture, you'd be able to feel ridges and dips. This is where van Gogh has squirted the paint straight from the tube onto the canvas and made patterns in it with the hard end of his brush.

If you were going to paint a vase of flowers, what kind of flowers would they be? Could you paint the whole picture by using different shades of the same color?

In the late summer of 1888, van Gogh painted four pictures of sunflowers. He seemed to think that two were better than the others and only added his signature to these two. Many artists sign their finished paintings, writing their full name or just their family name. Van Gogh has signed with only his first name, Vincent. **How do you sign your paintings?**

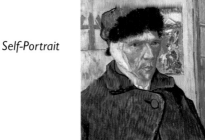

Self-Portrait

Van Gogh was a man with very strong feelings, and he sometimes behaved in a strange way. On Christmas Eve, a few months after he had finished *Sunflowers* and following an argument with his close friend, the artist Paul Gauguin, he cut off part of his left ear. At half-past eleven at night he gave it to a woman, asking her to take good care of it, and then went home. He was found unconscious in bed by the police the next morning. Soon after that, van Gogh painted this picture of himself. He painted it while looking at his reflection in a mirror, which is why his bandage appears to be covering the wrong ear.

Although today his paintings are some of the most expensive in the world, van Gogh sold only one in his lifetime.

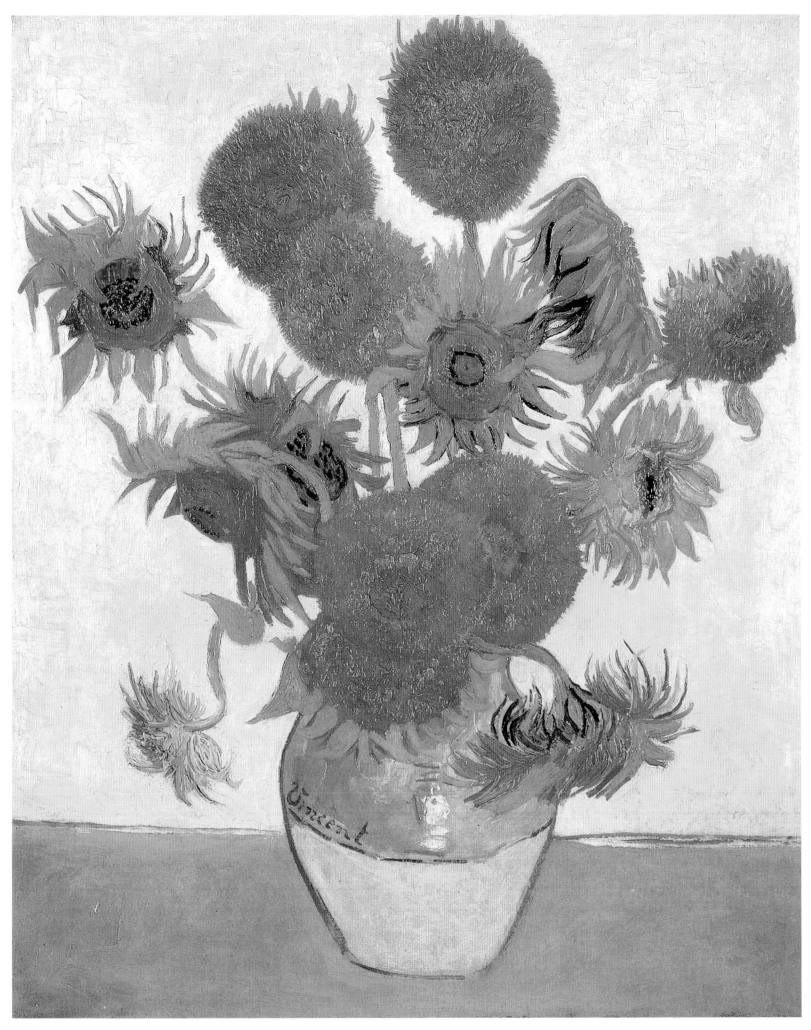

Sunflowers

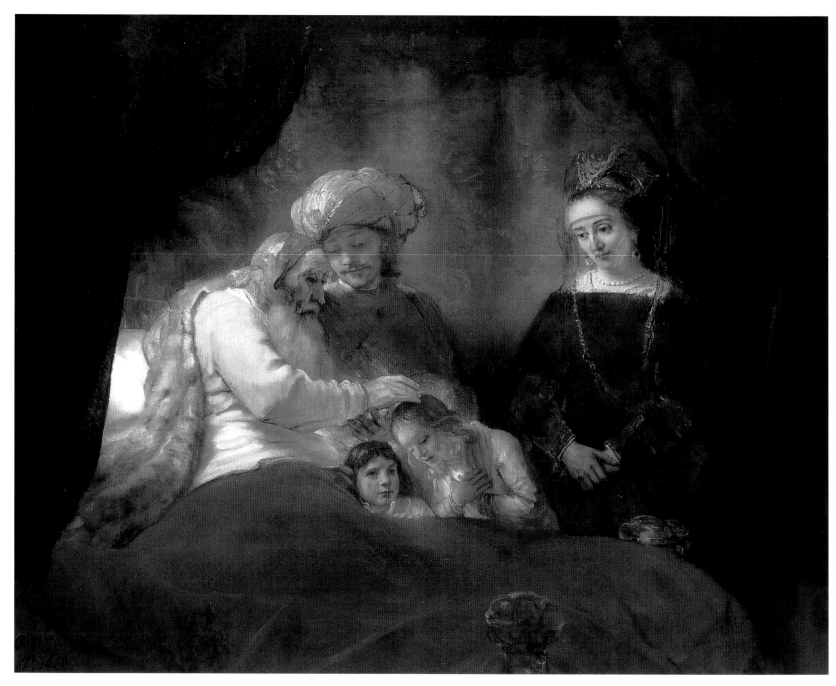

Jacob Blessing

Feelings

A whole family is shown here: grandfather, parents, and children. But it's not a happy gathering. The old man in bed looks frail and the mother, with her big brown eyes and her folded hands, looks very thoughtful.

The old man is a character from the Bible. His name is Jacob. His son, standing next to him and wearing a turban, is called Joseph. Joseph has brought his own sons to be blessed by their sick grandfather before he dies.

Jacob is blind, so Joseph needs to guide his father's hand to place it on the little boy's head. As his grandfather touches the top of his head, the little boy leans over and crosses his own hands on his chest as a sign of respect.

It's very difficult to paint things that you can't see or touch, like feelings. Rembrandt makes us understand how these people are feeling by trying to imagine how they would have behaved. He chose to paint them making small gestures that reflect their sadness. He also chose to use dark colors. **What do you think these people are feeling?**

Rembrandt's own life was rather sad, as you can see from his face in this self-portrait.

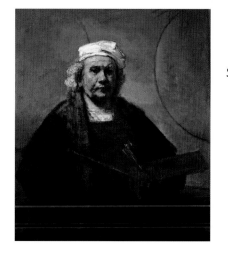

Self-Portrait

He was a rich and successful portrait painter, but later in life he lost his entire fortune. Most of his children died before him, and so did both his first and second wives. Perhaps it was because of his own suffering that Rembrandt could understand and show other people's feelings so well.

Movie star

Andy Warhol was a big fan of famous people such as the glamorous movie star Marilyn Monroe. He made over 70 portraits of her, all slightly different.

Warhol made copies of this black-and-white publicity photograph of the actress.

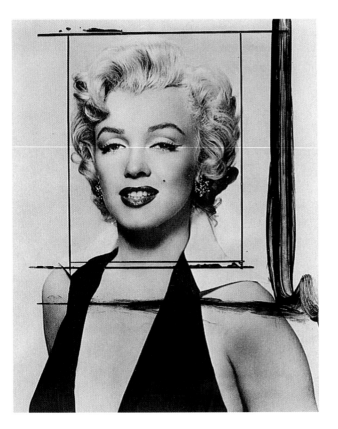

He then colored each in a different way. Sometimes he made Marilyn's hair yellow, her eyeshadow blue and the background orange. In other pictures, the background is yellow, and sometimes the whole picture is in one color. When you see so many versions together, it's a bit like a game of "spot the difference."

Warhol was called a Pop artist, because he made art from pictures of 'popular' things. He loved to make pictures of people and things that everybody could recognize, whether it was a dollar bill, Elvis Presley, or a can of the Campbell's soup he ate for lunch every day.

Warhol liked Marilyn Monroe because she was so famous. He was fascinated by the idea of fame. He once said that everyone in the world could be famous for 15 minutes.

Marilyn

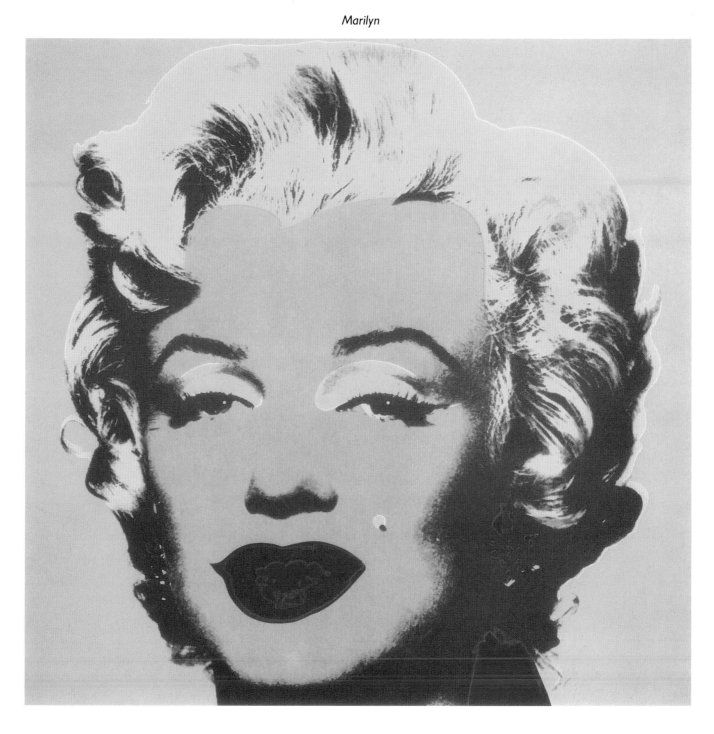

Who's your favorite movie star or pop star?

**If you were an artist, how many times would you make
pictures of him or her?**

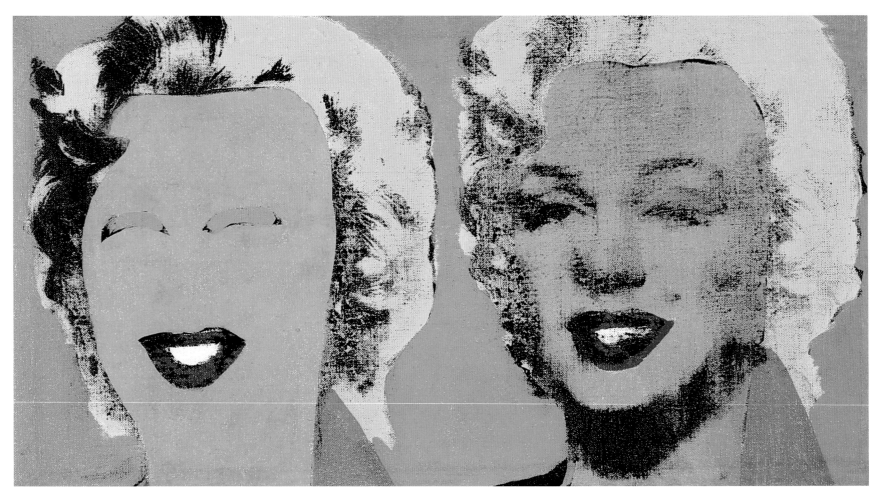

Two Marilyns

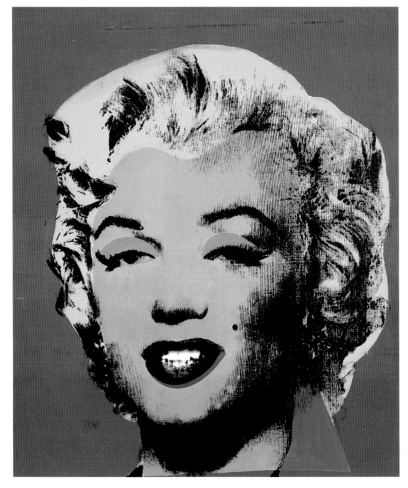

Red Marilyn

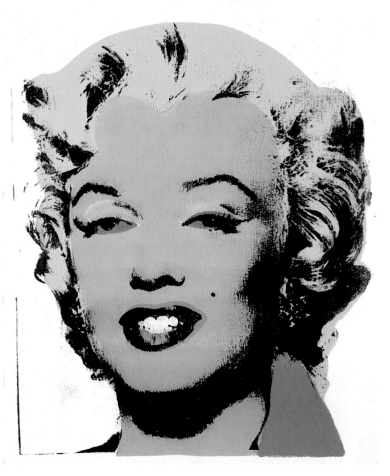

Lemon Marilyn

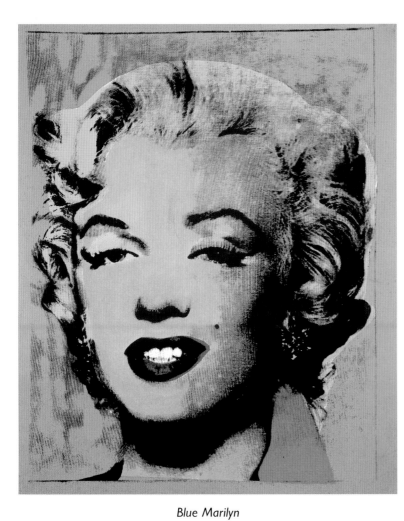

Blue Marilyn

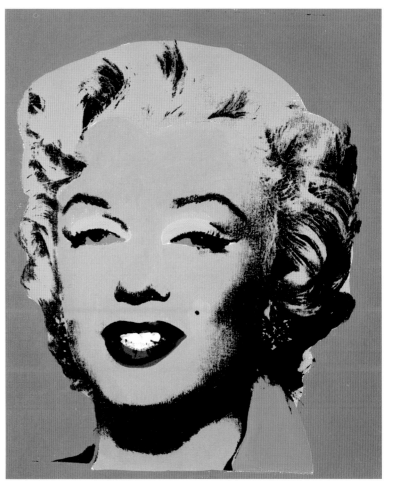

Peach Marilyn

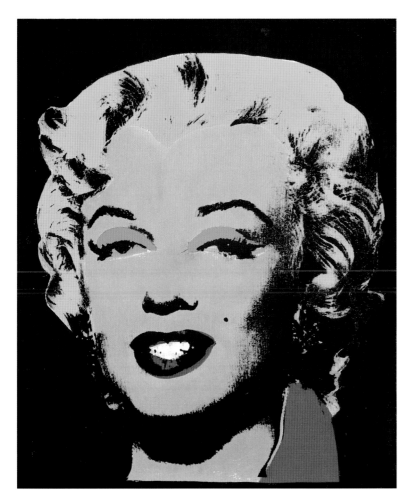

Licorice Marilyn

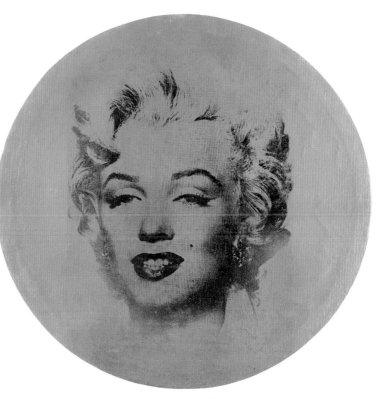

Round Marilyn

Detective work

You sometimes have to be a detective when you look at art. Paintings are often full of clues that the artist includes to help us work out who are the people in the picture or what's going on. It's not a coincidence that these two men are standing by a table that is stacked with gadgets. They are all there for a reason.

There are two globes. The one on the bottom shelf shows the earth (a terrestrial globe), and the one on the top shelf shows the planets (a celestial globe). There are two books, one wide open and the other almost closed. The big wooden object that looks like half a melon is a musical instrument called a lute. Next to it there are some flutes.

What does the picture tell you about these two men?
Hans Holbein has included these objects to tell us that the men are well traveled (the terrestrial globe), interested in astronomy (the celestial globe), that they are musical (the lute and the flutes) and well educated (the books). The man on the left is the French Ambassador to England, and the man on the right is a French bishop.

What is that strange shape on the tiled floor between the men? If you keep this book flat and move your head to the right and close to the page, this strange blob changes into a skull. Holbein can't help bringing these two over-confident men down to earth by including this frightening reminder that life doesn't go on for ever. Holbein wants to tell us that however much these men might know and however powerful or rich they might be, they are only human and will die one day, like everyone else.

If a detective came into your bedroom, would he or she be able to guess what kind of a person you are by looking at the pictures you have on the walls and the possessions you have on the shelves?

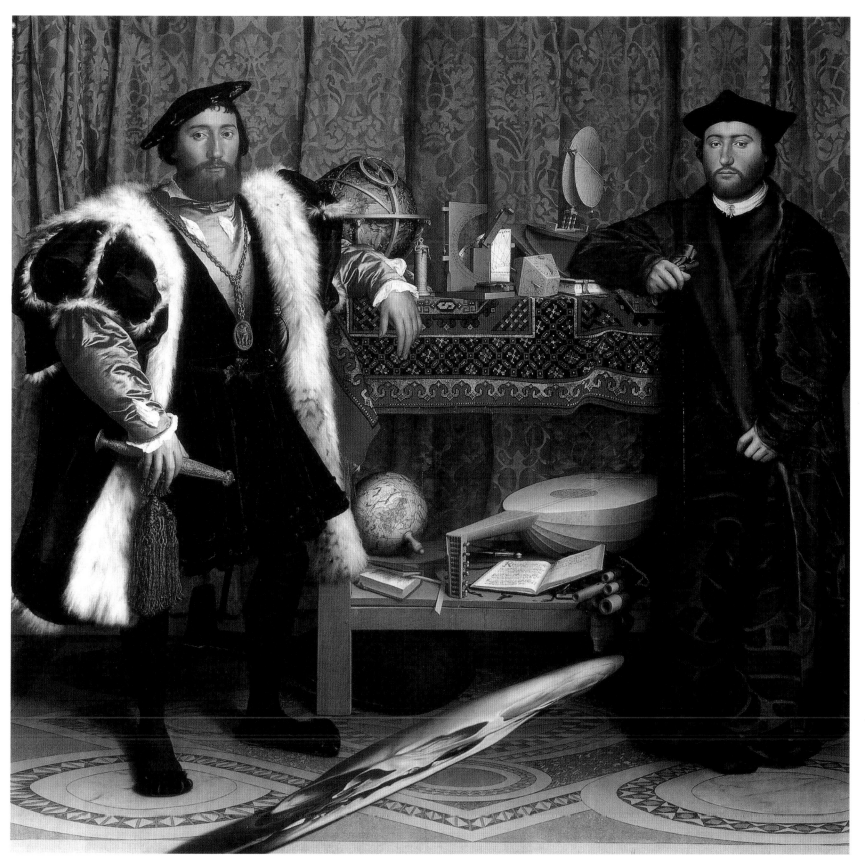

The Ambassadors

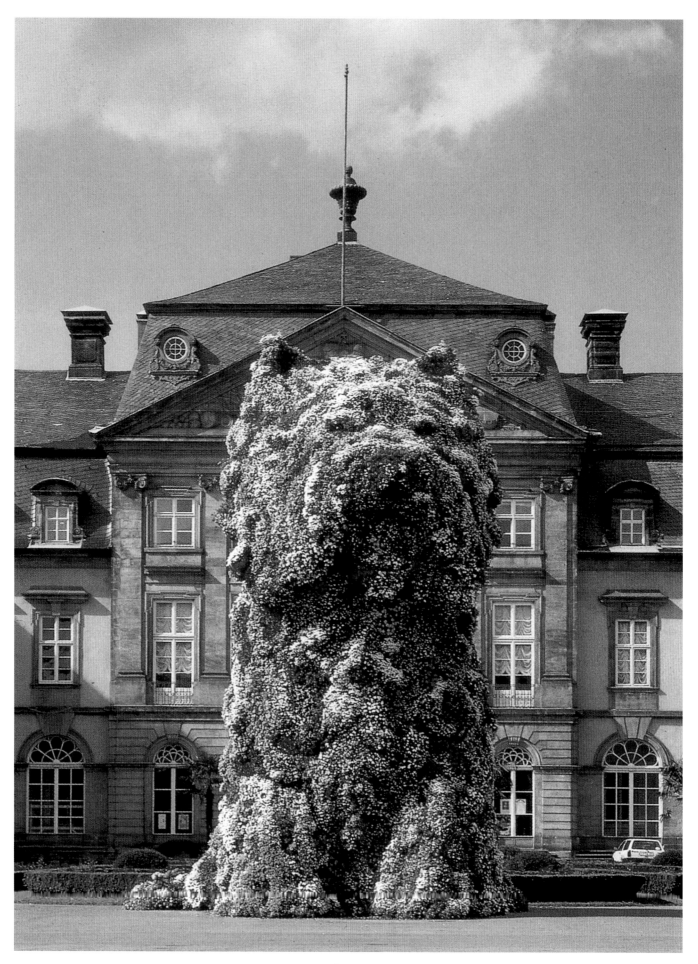

Puppy

Jeff Koons

Flower power

Instead of painting flowers and plants to make a picture of a person as Arcimboldo does on pages 4 and 5, Jeff Koons has used the plants themselves to make this work of art. This giant puppy is about 38 feet high. It took 50 people to build it, and it's made up of 25 tons of soil and over 70,000 flowering plants, including begonias, petunias, and marigolds.

Instead of a museum guard to look after it, the sculpture needs a team of gardeners who check it every day and replace old plants with new ones. As you can see, the puppy is as big as a three-story building, and Jeff Koons had to think as an architect does when he made it. The sculpture contains a complicated automatic watering system to keep the flowers alive as long as possible.

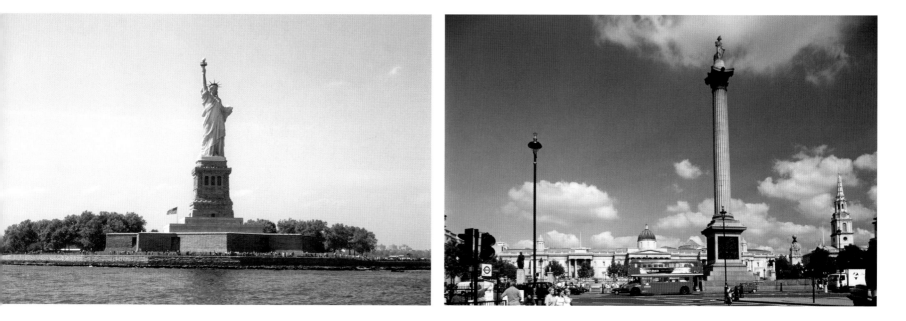

How many other giant, outdoor sculptures can you think of around the world? What about the Statue of Liberty in New York or Nelson's Column in London? They were built to honor important events in history and are made of hard, long-lasting materials like stone or metal.

Do you think Koons wanted to celebrate an important event?
He said that he just wanted to make a monument to love, warmth, and happiness, but, most of all, I think he wanted to put a smile on our faces!

A puzzle

Two ladies with similar dresses, hairstyles, and hats, a small boy, a pair of red platform shoes, two dogs, a parrot, a peacock, and two doves. What's going on here? Unfortunately, we may never know. What we see here is only a part of the original painting. It seems that, as with many old paintings, this picture was cut up into at least two parts. No one knows where the other parts are.

At least one missing part was on the left-hand side. We can only see half of the second shoe, and the dog biting the stick seems to have been cut in two. Perhaps one day someone will find a painting showing half a red shoe and the body of a dog on the right-hand side!

What are these two ladies looking at? Although the lady closer to us is playing with the two dogs, she is looking at something else.

Is the other lady looking at the same thing? Did the left-hand side show more ladies dressed in the same way? Could there have been more animals and birds? Or perhaps these ladies are nannies watching over children as they play. Look at the white dog. He's looking at us as if he's trying to tell us what's going on.

We know that Vittore Carpaccio was more interested in storytelling than in making the people and animals in his paintings look realistic. But without the other half of the painting, we will never know what the story was.

There may also be something missing from the top of this painting. The plant that stands next to the doves seems to have been cut off. It may have been complete in the original picture. **What do you think?**

Two Venetian Ladies on a Balcony

Can you imagine what else might have been on the left-hand side of this painting?

A garden

Claude Monet loved gardens. He lived in a big house in Giverny, just outside Paris, where he created the most beautiful garden. There were flower beds overflowing with plants, a lily pond, and this Japanese-style bridge. He loved gardens so much that he spent 27 years painting them.

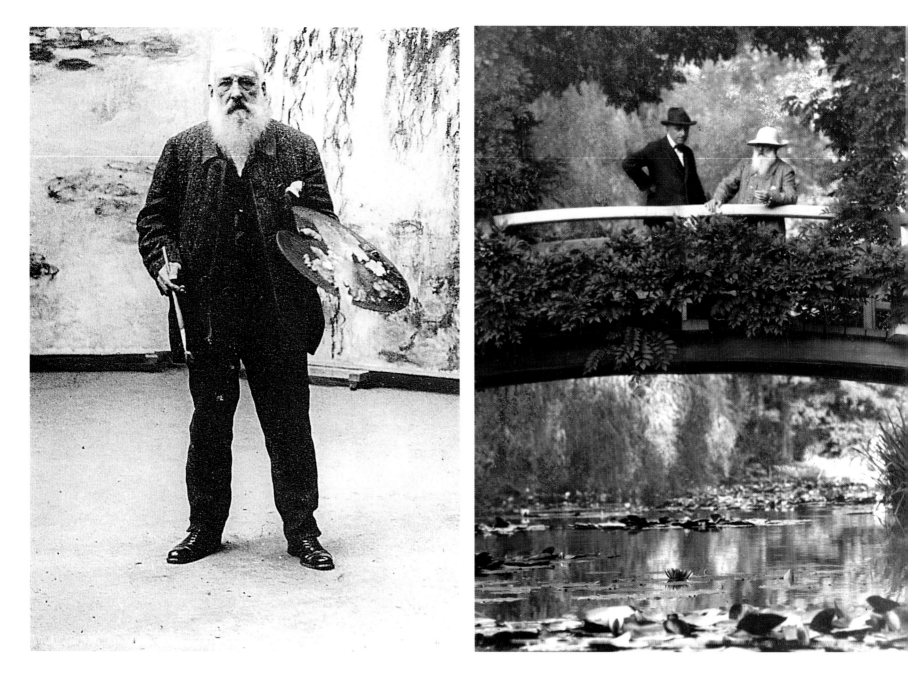

Unlike some of the other artists in this book, Monet wasn't interested in painting details. He wanted to give the feeling of being in a garden rather than to describe every flower and leaf.

Look at the difference between Monet's leaves and the ones painted by Rousseau (on page 40). Rousseau's leaves are clearly painted with crisp outlines. In Monet's painting it's difficult to tell where the flowers of the lilies end and the leaves begin.

Even though there is very little detail in this picture, we know that there are bulrushes by the side of the pond and weeping willows hanging behind it, and that the flowers on the lake are lilies.

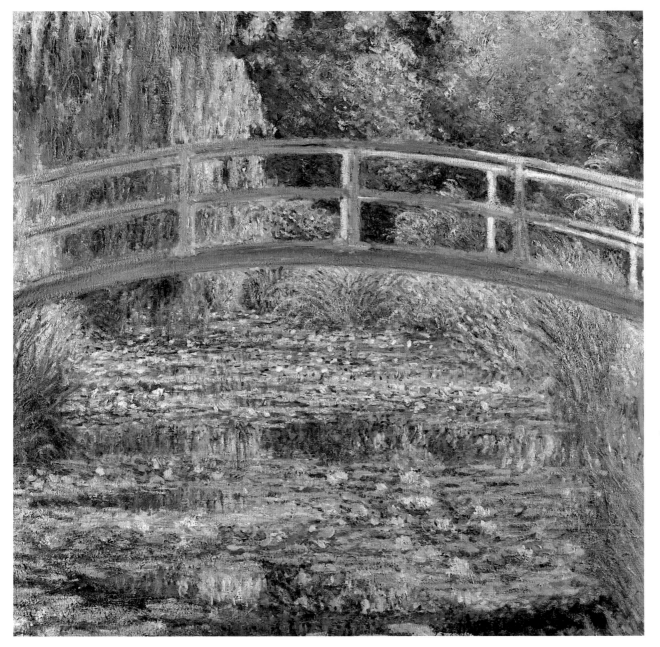

Waterlily Pond

Monet wanted to capture the flickering sunlight shining through the leaves of the trees onto the lily pond. To do this, he used thousands of delicate dabs of color. By choosing his colors carefully, he was able to create the light, airy impression of a summer's day. Because he painted in this way, he was called an Impressionist painter.

Art or furniture?

Are these objects art, or pieces of furniture? Donald Judd actually made both, so sometimes it's a little confusing. Judd's sculptures were often made in the same way as furniture. He would draw a detailed diagram explaining what he wanted the sculpture to look like, how big he wanted it to be, and what materials and colors to use. He would then send the diagram to a factory where someone else would very carefully follow his instructions. Once the workman had finished, Judd inspected the sculpture and either approved it or sent it back to be redone.

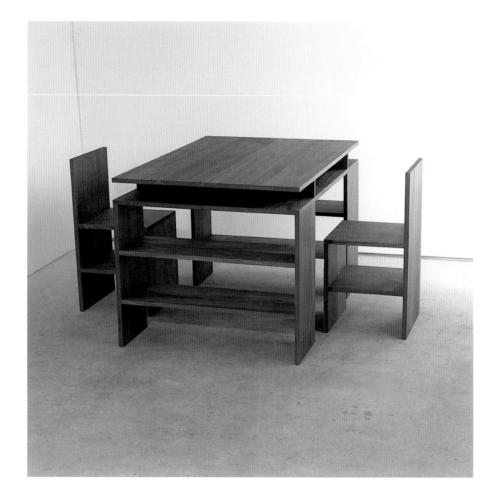

So how can you tell art from furniture? Furniture has to be functional like the desk and chairs seen above. This means that you need to be able to sit on it if it's a chair, or at it if it's a table. Art has no practical use whatsoever. It is not made to be used, but to be looked at and thought about.

The sculpture below is called a "stack". It's unusual because, instead of standing on the floor, or on a platform, like sculptures by most other artists, it's attached to the wall. It comes out of the wall into the room, and sometimes looks as if it's just floating there, not attached to anything.

Untitled

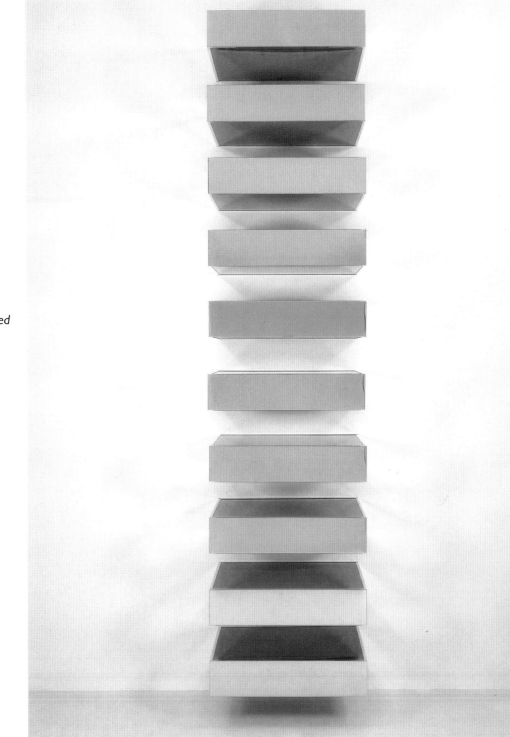

Judd liked his sculptures to look as if they were made by a machine. Each box in this stack is exactly the same as the next. They are all made with extreme accuracy, and placed on the wall very carefully. The space between each piece is exactly the same size as the pieces above and below it. To Judd, the spaces created between these metal boxes are just as important as the boxes themselves.

Judd loved space. He chose to move away from the crowded streets of New York City and went to live in the middle of the desert in Texas. There, near the small town of Marfa, he created enormous sculptures in the wide open landscape. These concrete works are large enough to stand in and together they stretch over half a mile.

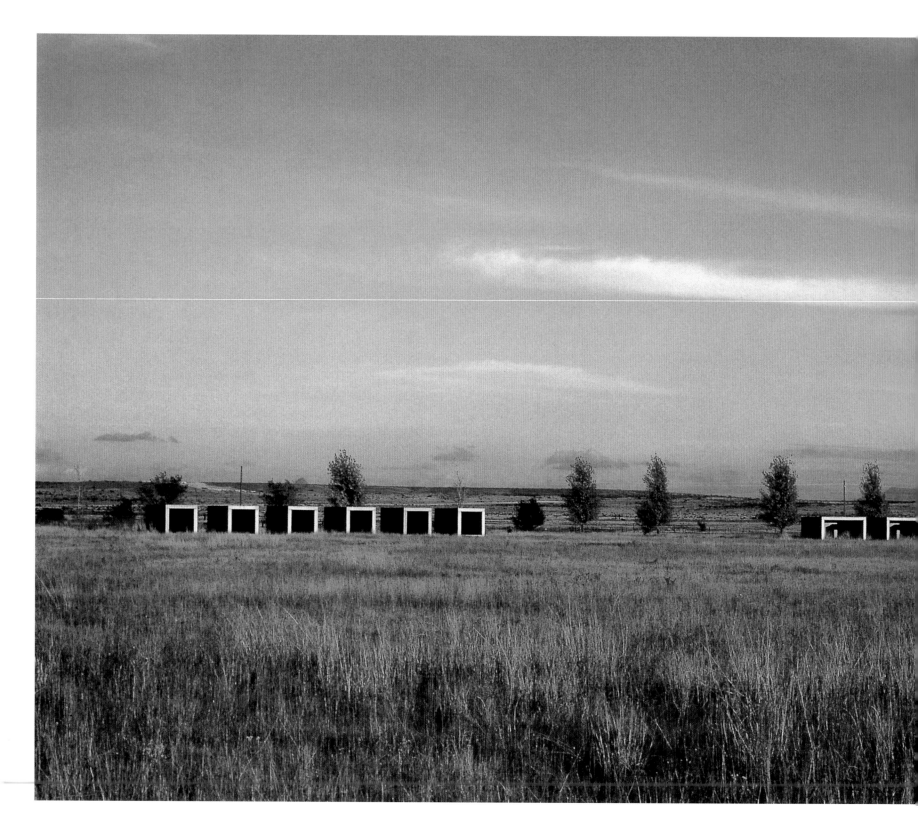

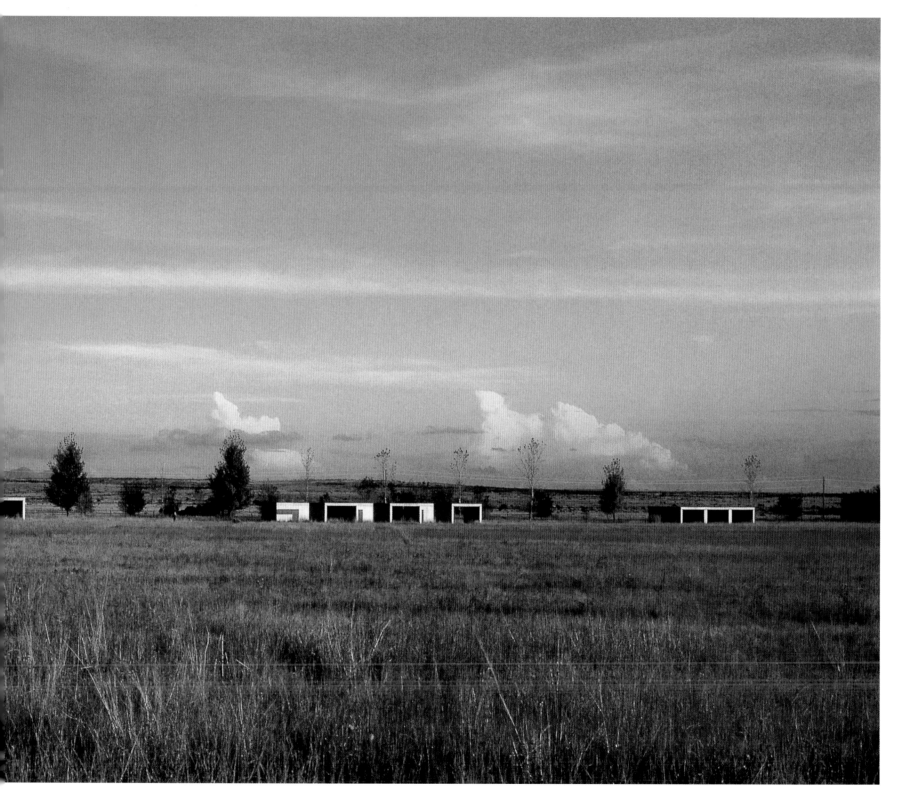

Space has a very big impact on the way that we feel and behave. If you are in a small, cramped room, do you behave in the same way as if you were outdoors in a wide open space with a big sky and distant horizon?

Showing off?

This painting celebrates a marriage. Jan van Eyck has chosen to paint the couple inside their house, so that he can tell us more about them.

The man in this painting is Giovanni Arnolfini. We know that Giovanni was an Italian merchant who exported beautifully made cloth from Bruges in Belgium, where he lived, to Italy. To show us Giovanni's interest in fabrics, van Eyck has tried to include many different types and textures of cloth and has painted them in great detail.

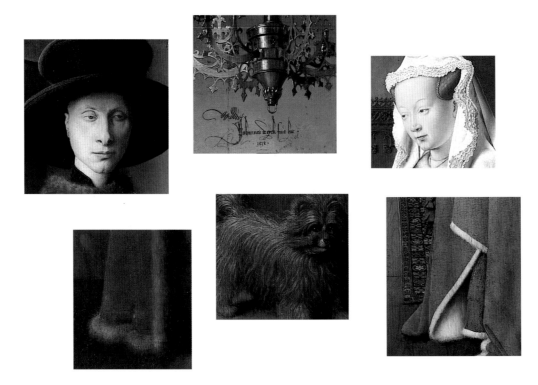

Giovanni's large hat is probably made of thick brown velvet, and his robe is trimmed with soft fur. His wife wears a starched, white headdress trimmed with Belgian lace, and her heavy green gown, with its pleated bodice, has fancy edges on the sleeves and is also edged with fur. Beneath her green flowing robe, she is wearing a beautiful blue dress that looks as if it is made of satin. She is standing in front of a woven carpet, and the bed behind her is covered in a rich, red bedspread. Everything is painted in great detail—look at the brass chandelier, with the single candle, above their heads. You can almost count the hairs on the little dog at their feet.

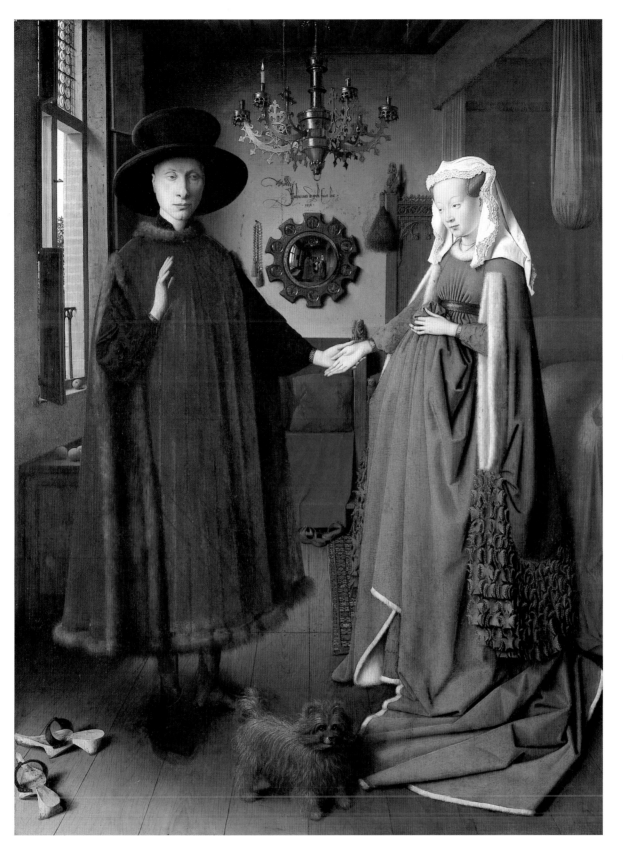

The Arnolfini Portrait

I think that van Eyck was showing off a little in this picture. He and his brother, who was also an artist, invented a way of mixing paints and linseed oil that enabled them to paint the tiniest details. I think he used this picture to show how good this technique was. He was so proud that, on the back wall of the room, he has written, in Latin, *Johannes de eyck fuit hic* (Jan van Eyck was here), to make sure that everyone knew it was he who had painted the picture.

Altdorfer Page 37
Battle of Alexander at Issus, 1529
oil on wood panel
52¼ x 47¼ in (132.7 x 120 cm)
Alte Pinakothek, Munich, Germany

Albrecht Altdorfer was born
in the city of Regensburg in
Germany around 1480. He died
there in 1538.

Arcimboldo Pages 4–5
Spring, Summer, Fall and *Winter*, 1573
all oil on canvas
all 30 x 25 in (77 x 63 cm)
Louvre Museum, Paris, France

Giuseppe Arcimboldo was born
in 1527 in Milan, Italy. He spent
much of his life in the royal
courts of Vienna and Prague,
and died in Milan in 1593.

Bassano Page 29
The Animals Entering the Ark, about 1590
oil on canvas
81½ x 104⅜ in (207 x 265 cm)
Prado Museum, Madrid, Spain

Jacopo Bassano was born in
Bassano del Grappa (he took
his name from his home town)
in Italy in around 1510. He died
there in 1592.

Botticelli Page 19
Spring, around 1470–80
tempera on wood panel
80 x 123½ in (203 x 314 cm)
Uffizi Gallery, Florence, Italy

Sandro Botticelli spent his life
in Florence, Italy. He was born
in 1445 and died in 1510.

Bruegel Page 9
Peasant Wedding Feast, around 1566–7
oil on wood panel
45 x 64 in (114.3 x 162.6 cm)
Kunsthistorisches Museum,
Vienna, Austria

It is thought that Pieter
Bruegel the Elder was born
in Brogel in Flanders (which
is now part of Belgium)
around 1525. He died in
Brussels in 1569.

Carpaccio Page 67
Two Venetian Ladies on a Balcony,
about 1495–1500
oil on wood panel
64½ x 37 in (164 x 94 cm)
Museo Correr, Venice, Italy

Vittore Carpaccio was born
in Venice, Italy around 1460.
He died there in 1525.

Christo and Jeanne-Claude
Page 24–5
The Pont Neuf Wrapped, Paris, 1975–85
1975–85
439,989 square feet (40,876 square
metres) of woven nylon and 42,900 feet
(13,076 metres) of rope. Now dismantled

Page 26
*Surrounded Islands, Biscayne Bay,
Greater Miami, Florida, 1980–83*, 1980–3
6.5 million square feet (603,850 square
metres) of pink fabric floating
around 11 islands. Now dismantled

In 1935, Christo was born
in Gabrovo, Bulgaria and
Jeanne-Claude was born in
Casablanca, Morocco. Christo
moved to Paris, where he
met Jeanne-Claude, in 1958.

Degas Page 33
The Rehearsal, 1873–4
pastel on canvas
23⅓ x 33 in (59 x 83.8 cm)
The Burrell Collection, Glasgow
Museums and Art Galleries, Scotland

Edgar Degas was born in 1834
in Paris, France and died there
in 1917.

Van Eyck Page 75
The Arnolfini Portrait, 1434
oil on wood panel
32¼ x 23½ in (81.8 x 59.7 cm)
National Gallery, London, England

Jan van Eyck was probably
born in Maaseik in the
Netherlands around 1395.
He died in Bruges, Flanders
(now part of Belgium) in 1441.

Giacometti Page 44
Walking Man, 1960
bronze
72 in high (183 cm)
Private collection

Page 45
Study for *Walking Man*, 1950
Oil on paper
20 x 26¾ in (57 x 68 cm)
Private collection

Alberto Giacometti was born
in 1901 in the Swiss village
of Borgonovo near Stampa.
He died in 1966 in Chur,
Switzerland.

Gilbert and George Page 6
Thumbing, 1991
hand-dyed photographs mounted
and framed
66½ x 56 in (169 x 142 cm)
Private collection

Page 7
The Singing Sculpture, 1970
table, glove, walking stick,
tape recorder and the artists

Gilbert (Proesch) was born
in the Dolomites, Italy in
1943, and George (Pasmore)
was born in Devon, England
in 1942.

Van Gogh Page 54
Self-Portrait with Bandaged Ear, 1889
oil on canvas
23⅝ x 19¼ in (60 x 49 cm)
Courtauld Institute Galleries,
London, England

Page 55
Sunflowers, 1888
oil on canvas
36⅙ x 28½ in (92 x 73 cm)
National Gallery, London, England

Vincent van Gogh was born
in Groot-Zundert in the
Netherlands in 1853 and died
in Auvers-sur-Oise in France
in 1890.

Hokusai Page 20 (from left to right)
Mount Fuji with Cranes, about 1830–2
woodblock print on paper
10 x 15 in (25.2 x 38 cm)
Private collection

Mount Fuji with a Fisherman, about 1830–2
woodblock print on paper
10⅛ x 14⅞ in (25.6 x 37.8 cm)
Private collection

Mount Fuji and Three Men on Horseback,
about 1830–2
woodblock print on paper
9⅞ x 14¾ in (24.9 x 37.6 cm)
Private collection

Page 21 (top)
Red Fuji, around 1823–9
woodblock print on paper
10¾ x 15 in (27 x 38 cm)
Private collection

Page 21 (bottom from left to right)
The Great Wave, about 1830–2
woodblock print on paper
10¼ x 15 in (25.9 x 38 cm)
Private collection

Mount Fuji with a Timber Yard,
about 1830–2
woodblock print on paper
10⅜ x 15¼ in (26.2 x 38.5 cm)
Private collection

Mount Fuji with a Kite, about 1830–2
woodblock print on paper
10 x 14¾ in (25.2 x 37.6 cm)
Private collection

Katsushika Hokusai was born
in Edo (which is now called
Tokyo), Japan in 1760. He died
there in 1849.

Holbein Page 63
The Ambassadors, 1533
oil and tempera on wood panel
81½ x 82½ in, (207 x 209 cm)
National Gallery, London, England

Hans Holbein the Younger
was born in Augsburg,
Germany in 1497 or 1498.
He died of the plague in
London, England in 1543.

Judd Page 70
Desk Set, 1982
hardwood
Desk 30 x 48 x 33 in (76 x 122 x 84 cm)
Chairs 30 x 15 x 15 in (76 x 38 x 38 cm)
Private collection

Page 71
Untitled, 1993
brass and plexiglass
180 in high (457.2 cm)
Private collection

Pages 72 and 73
Concrete Works, 1980–4
concrete
Chinati Foundation, Marfa, Texas, USA

Donald Judd was born in
Excelsior Springs, Missouri,
USA in 1928. He died
in New York, USA in 1994.

Koons Page 64
Puppy, 1992
flowering plants, steel, wood and soil
38 ft high (11.5 m)
Temporarily on display at Schloss
Arolsen, Germany, *Puppy* is now
permanently on display outside the
Guggenheim Museum in Bilbao, Spain

Jeff Koons was born in 1955
in York, Pennsylvania, USA.

Leonardo Page 15
Mona Lisa, 1503–6
oil on a wood panel
30¼ x 21 in (77 x 53 cm)
Louvre Museum, Paris, France

Leonardo da Vinci was born in
1452 in Vinci in northern Italy.
He died in France in 1519.

Martini Page 22
The Annunciation, 1333
tempera on wood panel
72½ x 82¾ in (184 x 210 cm)
Uffizi Gallery, Florence, Italy

Simone Martini was born
in Siena, Italy in about 1284.
In later life he traveled to
France, and died in Avignon
in 1344.

Miró Page 30
Women, Bird by Moonlight, 1949
oil on canvas
32 x 26 in (81.5 x 66 cm)
Tate, London, England

Joan Miró was born in
Barcelona, Spain in 1893 and
died in Palma, Spain in 1983.

Monet Page 68
Monet painting in his studio (left)
and in his garden with a friend (right)

Page 41
Waterlily Pond, 1899
oil on canvas
34¾ x 36¼ in (88 x 93 cm)
National Gallery, London, England

Claude Monet was born in
1840 in Paris, France. He
died at his house in Giverny,
just outside Paris, in 1926.

Picasso Page 35
Weeping Woman, 1937
oil on canvas
24 x 19⅝ in (60.8 x 50 cm)
Tate, London, England

Pablo Picasso was born in
Malaga, Spain in 1881 and died
in Mougins, France in 1973.

Pollock Page 11
Jackson Pollock painting *Autumn Rhythm:
Number 30, 1950* in 1950

Pages 12–13
Number 1, 1948, 1948
oil on canvas
68 x 104 in (172.7 x 264.2 cm)
Museum of Modern Art, New York, USA

Jackson Pollock was born
in Cody, Wyoming, USA in
1912, and died in Long Island,
New York, USA in 1956.

Rembrandt Page 56
Jacob Blessing, 1656
oil on canvas
69¼ x 82¾ in (176 x 210 cm)
Staatliche Kunstsammlungen,
Kassel, Germany

Page 57
Self-Portrait, 1663–5
oil on canvas
44¾ x 37 in (114.3 x 94 cm)
Kenwood House, London, England

Rembrandt van Rijn was born
in Leyden, the Netherlands in
1606. He died in Amsterdam,
the Netherlands in 1669.

Riley Page 16
Cataract 3, 1967
emulsion on canvas
87⅜ x 87¾ in (221.9 x 222.9 cm)
British Council, London, England

Page 17
Fall, 1966
emulsion on board
55½ x 55 in (141 x 140.5 cm)
Tate, London, England

Fission, 1963
tempera on board
35 x 34 in (88.8 x 86.2 cm)
Museum of Modern Art, New York, USA

Bridget Riley was born
in London, England in 1931.

Rousseau Page 40
The Monkeys, 1906
oil on canvas
57⅓ x 44½ in (145.5 x 113 cm)
Philadelphia Museum of Art,
Pennsylvania, USA

Henri Rousseau was born in
1844 in Laval, France and he
died in Paris, France in 1910.

Sherman Page 48 (from left to right)
Untitled, 1990
color photograph
13 x 10 in (33 x 25.4 cm)
Edition of 350

Untitled, 2003
color photograph
26 x 16 in (66 x 40.5 cm)
Edition of 350

Untitled No. 137, 1984
color photograph
71½ x 47¾ in (181 x 120.7 cm)
Edition of 5

Page 49
Untitled No. 96, 1981
color photograph
24 x 48 in (61 x 122 cm)
Edition of 10

Page 50 (from left to right)
Untitled No. 210, 1989
color photograph
67 x 45 in (170.2 x 114.3 cm)
Edition of 6

Untitled, No. 416, 2004
color photograph
55½ x 48½ in (141 x 123 cm)
Edition of 6

Untitled Film Still No. 35, 1979
black-and-white photograph
10 x 8 in (25.4 x 20.3 cm)
Edition of 10

Page 51
Untitled No. 119, 1983
color photograph
45½ x 94 in (115 x 239 cm)
Unique

Cindy Sherman was born in Glen Ridge, New Jersey, USA in 1954.

Turner Page 52
The Shipwreck, 1805
oil on canvas
67½ x 95 in (171.5 x 241.5 cm)
Tate, London, England

Page 53
Snowstorm: Steamboat off a Harbour's Mouth, 1842
oil on canvas
36 x 48 in (91 x 122 cm)
Tate, London, England

Joseph Mallord William Turner was born in London, England in 1775, and died there in 1850.

Velázquez Page 46
Las Meninas (Maids of Honour), 1656
oil on canvas
127 x 108½ in (318 x 276 cm)
Prado Museum, Madrid, Spain

Diego Velázquez was born in Seville, Spain in 1599. He died in Madrid, Spain in 1660.

Warhol Page 58
Black-and-white publicity photograph of Marilyn Monroe

Page 59
Marilyn, 1967
screenprint on paper
36 x 36 in (91.5 x 91.5 cm)
Private collection

Page 60 (clockwise from top)
Two Marilyns, 1962
acrylic and silkscreen ink on linen
12 x 21¾ in (30.5 x 55.2 cm)
Andy Warhol Estate, New York, USA

Lemon Marilyn, 1962
acrylic and silkscreen ink on linen
20 x 16 in (50.8 x 40.6 cm)
Private collection

Red Marilyn, 1962
acrylic and silkscreen ink on linen
20 x 16 in (50.8 x 40.6 cm)
Irving Blum, New York, USA

Page 61 (clockwise from top left)
Blue Marilyn, 1962
acrylic and silkscreen ink on linen
20 x 16 in (50.8 x 40.6 cm)
The Art Museum,
Princeton University, USA

Peach Marilyn, 1962
acrylic and silkscreen ink on linen
20 x 16 in (50.8 x 40.6 cm)
Private collection

Round Marilyn, 1962
silkscreen ink and gold on linen
17¾ in diameter (45.1 cm)
Private collection

Licorice Marilyn, 1962
acrylic and silkscreen ink on linen
20 x 16 in (50.8 x 40.6 cm)
Private collection

Andy Warhol was born in Pittsburgh, Pennsylvania, USA in 1928. He died in New York City, USA in 1987.

Wood Page 42
American Gothic, 1930
oil on board
29¼ x 24½ in (74.3 x 62.4 cm)
Art Institute of Chicago, USA

Grant Wood was born near Anamosa, Iowa, USA in 1892. He died in Iowa City, Iowa, USA in 1942.

This book was conceived by Amanda Renshaw, Alan Fletcher and Gilda Williams Ruggi
Texts by Amanda Renshaw and Gilda Williams Ruggi
The publishers would like to thank the following for their advice and assistance:
Jane Ace, Chris Kloet, Glenn McCance, Gill Munton, Mari West and the Head Teacher and pupils
of Ruskin Junior School, Wellingborough, England.

Picture Credits

© ADAGP, Paris and DACS, London, 2005: 44–5; © ARS, NY and DACS, London, 2005: 10;
© ARS, NY and DACS, London 2005 / Digital Image, The Museum of Modern Art, New York / Scala,
Florence: 12–13; Artothek / Joseph S Martin: 14; Artothek / Photobusiness: 8–9; © BPK, Berlin, 2005 /
Photo: Hermann Buresch / Original: Alte Pinakothek, Munich: 38–9; © Christo 1985. Photograph
Wolfgang Volz: 24–5; © Christo 1983. Photograph Wolfgang Volz: 27; © Estate of Hans Namuth,
courtesy Pollock-Krasner House and Study Center, East Hampton, NY: 11; © Gilbert & George: 6–7;
Art © Judd Foundation. Licensed by VAGA, New York, NY / Photograph Deborah Denker: 70; Art
© Judd Foundation. Licensed by VAGA, New York, NY / Photograph Todd Eberle: 72–3; Art © Judd
Foundation. Licensed by VAGA, New York, NY / Photograph Ellen Page Wilson: 71; © Jeff Koons: 64;
© Pawel Libera / Corbis: 65R; © Succession Miró, DACS, 2005: 30; © The National Gallery, London:
74–5; The New York Times Photo Archives: 68R; © Succession Picasso, DACS, 2005: 35; © Bridget
Riley: 16–17; © Royalty Free / Corbis: 65L; © 1998, Photo Scala, Florence: 4L; © 1990 Photo Scala,
Florence: 5BL, 5BR; © Cindy Sherman, Courtesy Metro Pictures: 48–51; © Photo: Tate, London 2005:
52; © Andy Warhol Foundation for the Visual Arts, Inc: 59–61; The Archives of the Andy Warhol
Museum, Pittsburgh. Founding Collection, Contribution the Andy Warhol Foundation for the Visual
Arts, Inc.: 58; Art © Estate of Grant Wood/Licensed by VAGA, New York, NY: 42–3

Phaidon Press Inc.
180 Varick Street
New York, NY 10014

www.phaidon.com

First published 2005
Reprinted 2006 (twice), 2007, 2008

© 2005 Phaidon Press Limited

ISBN 978 0 7148 4530 2 (US Edition)

A CIP catalogue record for this book
is available from the British Library

Art directed by Alan Fletcher and designed by Jason Ribeiro
Printed in China